W9-AFF-012

Donna Kay Beattie

Assessment in Art Education

Davis Publications, Inc., Worcester, Massachusetts

ART EDUCATION IN PRACTICE SERIES

Marilyn G. Stewart

Editor

Donna Kay Beattie

Assessment in Art Education

Series Preface

Follow an art teacher around for a day—and then stand amazed. At any given moment, the art teacher has a ready knowledge of materials available for making and responding to art; lesson plans with objectives for student learning; resources for extending art learning to other subjects; and the capabilities, interests, and needs of the students in the art room. Working with a schedule that sometimes requires shifting several times a day from working with students in preschool to those in elementary, middle, and high school, the art teacher decides what to teach, how to teach it, whether students have learned it, and what to do next. The need for rapid decision making in the artroom is relentless.

The demands continue after school as the art teacher engages in assessment of student learning, curriculum planning, organization of materials, and a wide range of activities within the school community. Although most teachers want to be aware of and to integrate into their teaching new findings and developments within their field, they are pressed to find the time for routine, extensive reading of the literature.

Art Education in Practice provides the art teacher, museum educator, student, scholar, and layperson involved in art education with an overview of significant topics in art education theory and practice. The series is designed to meet the needs of art educators who want to know the issues within, the rationales provided for, and the practical implications of accepting curricular proposals presented from a variety of scholarly and political perspectives.

The emphasis of the series is on informed practice. Each text focuses on a topic that has received considerable attention in art education literature and advocacy statements, but one that has not always been accompanied by clear, concise, and accessible recommendations for the classroom. As new issues arise, books will be added to the series. The goal of the series is to complement the professional libraries of practitioners in the field of art education and, in turn, enhance the art-related lives of their students.

Editor's Introduction

Ten years ago, I conducted a graduate seminar on curriculum in which the students were all experienced art teachers. Among other things, we explored the implications of expanding art programs to include content and skills in art history, art criticism, and aesthetics, along with those of studio production. After listing numerous learning objectives associated with such a comprehensive art curriculum, I asked the teachers how they would determine whether and to what extent their students had learned what they had intended them to learn. I can still remember how quiet the room was as these teachers considered my question. One member of the class suddenly surprised herself and the rest of the class as she replied, "Well, I suppose . . . I could give them a . . . test." The idea of testing students in an art class was foreign to her and to her classmates. The truth is, not many art teachers took evaluation very seriously in those days. And there is an explanation for this.

Although most art teachers and some advocates believed as they do today that art has a crucial role to play in the general curriculum, art was considered by others to be a "special" subject—not quite "extra-curricular," but almost. The prevailing view was that art class provided a time for students to express themselves creatively, building self-esteem in the process. Students often were not to be assigned grades. Even among art teachers, the debate about grading was tied to the belief that learning in art could not be quantified or, for that matter, specified.

Things have changed since that time. As art educators increasingly have made explicit what has been implicit in the long-standing claims for the benefits of education in art, we have learned that we can, indeed, specify art content and skills.

Currently, all educators are being asked to take evaluation and assessment seriously. In school districts across the country, art teachers are being asked to join their colleagues across the curriculum in workshops and programs on assessment. Although art teachers are included in the directives, their special needs and concerns are not typically addressed in these mandatory sessions.

In this informative book, Donna Kay Beattie provides the art teacher with what these assessment workshops have generally excluded. Drawing upon her vast knowledge of the subject and considerable experience working with art teachers here and abroad, she translates important developments in assessment theory into solid, engaging, practical strategies for the art classroom.

Grounded in an approach to the study of art that is comprehensive, she provides many examples of ways to determine the extent to which students have learned what art educators have outlined as important learning in the four disciplines of art. She demonstrates that assessment need not be limited to tests; indeed, her many examples show that assessment can be seamlessly integrated with instruction.

As art teachers work to develop assessment programs at the classroom and district levels and beyond, they will want to keep this book close at hand. Beattie provides a thorough explanation of the key concepts and vocabulary of educational assessment. Art teachers need not be outside the assessment loop. Instead, as they incorporate the author's suggestions for integrating sound assessment practices within their programs and share these with their colleagues, they may find their work leading the way in assessment efforts across the curriculum.

Marilyn G. Stewart

Publisher: Wyatt Wade
Editorial Director: Helen Ronan
Production Editor: Nancy Wood Bedau
Manufacturing Coordinator: Steven Vogelsang
Assistant Production Editor: Carol Harley
Editorial Assistance: Robin Banas
Copyeditor: Lynn Simon
Design: Jeannet Leendertse

Library of Congress Catalog Card Number: 97-075081
ISBN: 87192-363-7
10 9 8 7 6 5 4 3 2 1
Printed in the United States of America

Acknowledgments

A book on assessment requires discussion and trial
implementation of included strategies. To this end,
I wish to thank my undergraduate and graduate art
education students at Brigham Young University for
their comments regarding proposed strategies. Sharon
Heelis deserves a warm thank-you for her help in creat-
ing charts. A special thanks goes to editor Marilyn
Stewart for her help in organizing the structure of
this book and understanding my vision for it. More-
over, I deeply appreciate the efforts of my publisher
and copyeditors in clarifying and editing the text.

Donna Kay Beattie

Table of Contents

Listing of Assessment Strategies

Chapters 2 through 6 feature Assessment Strategies interspersed with the text. All strategies are listed here with their page numbers, for easy reference.

Introduction

Assessment has gained a worldwide momentum and is viewed by many as the means for achieving educational reform. Assessment in the artroom is an important component of this expanding educational assessment landscape. The art educator, along with every other "keeper of a discipline," is now required to be a part of this movement toward effective and integrated assessment.

My goal in writing this book is to help educators and preservice teachers in the field of art to view assessment as nonthreatening and integral to teaching art. *Assessment in Art Education* prepares the teacher—even those with very limited knowledge in the field of tests and measurement—to address assessment effectively as it relates to his or her own art classroom practices. Familiar art assessment strategies and procedures are presented with fresh insights that were gleaned from my worldwide studies of many different and highly successful art education assessment systems. The reader is also introduced to strategies that may be new to the art education field. Presented strategies delve much deeper than the assessment of content-based knowledge. Important thinking processes which are central to making and appraising art are highlighted. In this respect, the book enables the teacher of art to realize the strength of a well-crafted assessment strategy.

This book addresses major topics in the field of tests and measurement and describes them with a vision appropriate to the art classroom. Chapter 1 introduces the teacher to basic assessment terminology, necessary for any beginning study in the field. Principles of assessment are presented to introduce current worldwide theory and research in the field and to serve as guidelines for development of a personalized assessment program. Chapter 2 covers material familiar to the art educator, focusing on performance-based assessment strategies. A wide assortment of such strategies is presented. These are useful for assessing student learning and for teaching purposes. In particular, ideas for improving the strength of the art portfolio are presented.

The third chapter focuses on traditional strategies, discussing ways to improve the abilities of these strategies to assess higher-order thinking skills. Chapter 4 acquaints the reader with scoring and judging strategies that are necessary for evaluating the art performance. Chapter 5 emphasizes quick, easy, but sound formative strategies, which catch and analyze the steady stream of information flowing between teacher and students in the classroom. The sixth chapter explores summative assessment strategies with particular attention paid to the development of test blueprints, scoring rubrics, and grades and marks. Chapter 7 introduces an Assessment Guideline to help the teacher begin to put into practice sound assessment. The last chapter focuses on the major psychometric issues of validity and reliability. These crucial testing concepts are broached, without complicated mathematical formulas, as they appear necessary for classroom assessments. Regrettably, state, national, and international art assessment issues and practices are beyond the scope of this book.

The reader is encouraged to enter the assessment landscape as unfolded in this book, boldly and without trepidation, and to experiment with and modify the ideas and concepts I have set forth. To be successful, classroom art assessment, regardless of type or sophistication, must emerge from the environment of the school and accommodate the art curriculum and art students.

Chapter

1

Introduction to Art Assessment

Monday morning, Isabel Fuentes, ninth- and tenth-grade art teacher at Hamilton High School, found the following memo from the principal in her mailbox.

MEMO

TO: Isabel Fuentes, Art Specialist

FROM: Dr. Brown, Principal

SUBJ: Assessment of State Visual Arts Content Standards

Our school district is requiring that all educators, including art specialists, show significant evidence that their current curriculum is effectively meeting new state standards based on the national voluntary student standards in each of the disciplines. For this reason, you are asked to design and conduct an assessment that will yield evidence of student learning outcomes that meet the state visual arts standards. All assessment results, along with your interpretation of the evidence, will be submitted to the district curriculum specialist for review. If the results of your student assessment do not evidence sufficient learning pertaining to the new standards, then the district will require that your current curriculum be revised, or that a new curriculum, which addresses state standards more precisely, be written.

Ms. Fuentes' immediate reaction? A mixture of frustration and anger. She has worked very hard to get her classes and curriculum in shape. Like many other teachers, despite her best efforts, she frequently feels overwhelmed by the amount of work looming before her.

"Great. One more interruption," she thinks as she rushes down the hall for her first period class. "One more piece of bureaucratic busywork. One more thing to rob me of time I should be giving to my students. I've read this memo three times, now, and I still don't understand what it is he wants us to do. I just have no time for nonsense like this."

Words and phrases like "significant evidence," "state content standards," "assessment," and "learning outcomes" elicit a kind of numbness in Ms. Fuentes. They are far removed from her concerns and the needs of the students facing her at 8:10 a.m. in Room 17B. Her reaction is not unique. For many harried teachers, the world of assessment, with its peculiar jargon and complex rules and regulations, seems to have little bearing on the problems of instructional technique, curriculum, and classroom management they grapple with daily.

Why Bother?

What is assessment? What does it have to do with real teaching? Why does it deserve teachers' time and attention?

Simply defined, *assessment* is the method or process used for gathering information about people, programs, or objects for the purpose of making an evaluation. Assessments occur at the classroom, district, state, and national levels. Every educator, regardless of discipline emphasis, knows from experience the effect assessment outcomes can have on his or her students, program, or school curriculum. National assessments, for example, and their evalua-

tion of what students across the nation do not know and are not able to do, have, in many cases, elicited public outrage. Public opinion has proven a powerful force in reforming the content and emphasis of the educational enterprise. In an educational setting, assessment provides a powerful tool for dictating institutional goals, initiating educational reform, and restructuring programs from the top down.

Classroom teachers daily make decisions about student achievement, the effectiveness of instructional methods and materials, and curriculum soundness. Students' progress depends very much on teachers making wise decisions about these issues. Information, on which to base sound decisions, needs to be gathered. Assessment is the means for gathering the information required in the classroom and beyond. Research has shown that most teachers spend nearly one half of their work day doing assessment-related work.[1] Understanding assessment and using the strategies and procedures suggested in this text will give art educators the tools they need to take the guesswork out of such decisions.

Finally, and perhaps less well understood, is the extent to which effective assessment techniques can improve classroom instruction, empower students, heighten student interest and motivation, and provide teachers with ongoing feedback on student progress. An effective art assessment program enables the art educator to diagnose student strengths and weaknesses early and on a regular basis, to monitor student progress, to improve and adapt instructional methods in response to assessment data, and to use information about students individually and as a group to manage the classroom more effectively.

In short, effective classroom assessment is not a meaningless task that robs teachers of valuable teaching time. Rather, it is an integral component of

quality teaching. Preassessing for prior knowledge, building on prior knowledge through instruction, reassessing, reteaching based on assessment findings, and final assessing are all part of sound classroom teaching practices. Properly handled, classroom assessment does not interrupt instruction, but blends seamlessly with the teaching process for the purpose of learning.

Recent Developments in Theory and Research

Just as assessment alters the educational system, so the educational system alters assessment. In response to reforms in education, the assessment community is itself engaged in a reform movement. The field of tests and measurements, for example, which witnessed steady growth and evolution through the nineteenth and twentieth centuries, is currently experiencing rapid and sometimes radical transformation fueled largely by an increased understanding of human growth and development and innovations in computer technology.[2]

As instruction today increasingly emphasizes thinking and reasoning processes, metacognitive processes, and other types of knowledge, assessment experts are responding with strategies for assessing knowledge related to content, processes, conditions, self, motor skills, attitudes, preconceptions, misconceptions, and expanded notions of intelligence and creativity. Today, the "thinking curriculum," with its emphasis on higher-level cognitive abilities, is seen not only as a means for achieving educational goals but also as the right of every student, regardless of intellectual ability.

Chart 1 (see page 132) identifies sample processes and products related to each visual arts discipline: aesthetics, art criticism, art history, and art production. The listing is neither exhaustive nor presented

Terms to Know

alternative assessment Assessment that deviates from traditional pencil-and-paper item formats.

authentic assessment Assessment that uses realistic, meaningful, open-ended problems, true to a discipline.

didactic assessment Assessment that informs or teaches during the actual assessment. Didactic assessment encourages students to make new connections while revealing exiting knowledge.

dynamic assessment Assessment that intimately links testing to teaching. A teach-test-reteach format is integral to dynamic assessment. Examiners look for obstacles that hinder the performance, mediate, then reassess.

Terms to Know

As the assessment landscape expands more rapidly into the field of art education, the art educator is confronted almost daily with assessment terms. Some of those listed here and at other points in this book will be new to the art educator, and others will refer to assessment practices intrinsic to the visual arts.

assessment Method or process used for gathering information about people, programs, or objects for the purpose of evaluation.

assessment guideline Formal preparation of an assessment.

attainment targets or **exit criteria** Less formal than the term "learning objectives," these terms encompass not only intended student outcomes but also teaching toward those outcomes.

criteria Characteristics of something by which its quality can be judged or a decision about it can be made.

criterion-referencing A type of score referencing system that compares a student's score on a performance to a whole repertoire of behaviors, which are, in turn, referenced to the content and skills of a discipline. Criterion-referenced assessments do not compare students' performances to that of other students but to the standard of the criterion.

evaluation Judgments of value concerning the worth of any aspect of the educational enterprise, including student learning, teacher effectiveness, program quality, and educational policy.

formative assessment Refers to judgments made during the implementation of a program that are directed toward modifying, learning, or improving the program before it is completed.

learning objectives What students should be able to know, do, value, or feel at the completion of an instructional segment.[3]

metacognitive skills A cluster of complex skills that refers to awareness and understanding of oneself as a learner.

multiple validations Assessments made over time.

preassessment Assessment implemented prior to beginning an instructional program for the purpose of establishing a knowledge base.

process Act of carrying something out; a series of established and orderly steps.

product Something that is produced as a result of a process or procedure.

standards Qualifying thresholds of what is adequate for some purpose established by authority, custom, or consensus.[4] Distinction should be made between content standards and achievement standards. Content standards specify exit learning criteria and achievement standards specify achievement levels pertaining to exit learning criteria.

summative assessment Evaluates a completed program, procedure, or product.

1.1 Australian high-school students assembling portfolios. St. Peter's Lutheran School, Brisbane, Queensland, Australia. Photo: Donna Kay Beattie.

in a formal hierarchy or sequence. One thing the chart illustrates well is the crossover of processes among the disciplines. Practically speaking, this means that the art educator has many different opportunities for analyzing, observing, and measuring students' procedural knowledge. In addition, as the chart demonstrates, discipline-specific processes require that students use the most commonly identified complex reasoning processes: comparing, classifying, inducting, deducting, analyzing errors, constructing support, abstracting, analyzing perspectives, making decisions, investigating, inquiring, problem solving, and inventing.[5] Additional core thinking skills, based on those identified for cross-curricular assessment purposes in Queensland, Australia, are found in Appendix A (see page 131).

The Basics: What the Art Educator Needs to Know

Little of value is learned from assessment practices that are haphazard, inequitable, unrelated to learning objectives, or unjustifiable in terms of time required and information gleaned. Validity issues, such as test appropriateness, scoring, ethics, and equity are not esoteric issues of interest only to assessment scholars and theorists. In fact, they are intimately related to the everyday working of individual classrooms. Attentiveness to certain key, underlying principles, such as those listed in the following pages, will help the art educator ensure that he or she is moving toward effective, sound, and fair assessment practices.

One final, cautionary note: before attempting to address these principles, the art educator should first examine his or her teaching methods to be sure that they promote the types of learning prescribed in the principles. Planning a classroom assessment program responsive to these principles thus will have the added benefit of enriching the entire art curriculum.

 Assessment Hint

If you are considering establishing a quality assessment program, then do not let the principles listed on the following pages overwhelm you. The assessment tools you currently use in your art classroom or studio, such as the art portfolio, the visual journal, or simple, quick questions during instruction, may well address many of these principles. In addition, not all of the principles are applicable to every grade level. It is your decision to decide which ones will work best for you and your students.

Principles of Quality Classroom Art Assessment

Assessment is student-oriented and teacher-directed.
Student needs, interests, learning styles and strategies, and special considerations determine appropriate assessment strategies. Although the teacher creates and directs classroom assessments, he or she encourages, whenever possible, student participation in the conception and crafting of the assessment tools.

Assessment supports, rather than interferes with, instruction and course objectives.
Classroom assessment neither interrupts nor drives teaching. It should be neither cumbersome nor overwhelming for the teacher to manage. Only the most important learning objectives are selected for assessment.

Assessment is multi-layered.
A well-designed assessment task measures many levels of knowledge related to specific goals and skills. Students' artistic performance, whether reflective as in art history, art criticism, or aesthetics, or productive as in art studio products and processes, is most often complex and for that reason difficult to measure.[6] No single assessment criterion or strategy will give the art educator the breadth of information he or she needs in order to ascertain a student's artistic progress.

Assessment is continuous and focused on providing ongoing information.
Effective classroom assessment regularly scrutinizes students' strengths and weaknesses, specific problems and their underlying causes, and implies strategies for improvement, providing for the art educator feedback that reveals students' long-term progress toward a set of determined exit-level standards. In such an assessment environment, the most recent information, because it more validly represents student achievement, always supersedes earlier data.

Assessment is contextual and authentic.
Effective assessment meets the needs of students, the specific art program, the classroom environment, and the community. In addition, well-structured assessments include *authentic tasks*—tasks derived from the content and methods specific to each of the four art disciplines and/or tasks that require synthesized knowledge of their content and methods.[7]

Assessment represents an appropriate balance of formal and informal strategies.
Always, student learning should drive classroom assessment. Because the purpose of *formative assessment* is to gather data about students in the process of learning in an effort to change or modify behaviors that might be inhibiting learning, good classroom assessment places major emphasis on formative, rather than *summative*, assessments.

Assessment focuses on both products and processes.
Quality classroom assessment examines both products and processes, which means the *object of assessment* (the major focus around which an assessment is organized) can be either a product or a process or both. A *product* is the outcome of a process or procedure such as a painting, sculpture, critical review, or an art-historical timeline. A *process* is any one of numerous studio- or classroom-based activities that leads to production of an artwork or a cognitive-based product. Creating, analyzing, interpreting, evaluating, and presenting an argument are also examples of processes.

Assessment provides opportunities for students to revise and make changes in products and processes.
Effective art assessment tasks require that students revisit assignments at a later date and re-examine a theme, idea, product, working process, or series of experiments for the purpose of improving the original outcome. This type of assessment will give the art educator invaluable information about a student's

progress and growth. Student self-assessment and revision also address the issue of authenticity in as much as artists, aestheticians, critics, and art historians frequently rework, rethink, and rewrite earlier products.

Assessment is responsive to different types of knowledge.

The categories below describe six discrete types of knowledge that together encompass the three traditional educational domains: cognitive, psychomotor, and affective. Effective art assessments will address all six types.

1 Knowledge of the content of a discipline— includes facts, ideas, and generalizations related to specific disciplines.
2 Knowledge of skills and processes integral to a discipline, called *procedural knowledge*.
3 Knowledge concerning why certain procedures and processes are used and in which situations they are preferred, called *conditional knowledge*.
4 Knowledge concerning one's own strengths and weaknesses. Includes both factual and procedural knowledge and the ability to use these to achieve personal goals and objectives. Sometimes called *metacognitive skills*.
5 Knowledge concerning motor skills, such as how to manipulate tools of processes for a painting.
6 Knowledge about attitudes—includes information about traits, dispositions, motivations, interests, values, preferences, or other personal emotional states and habits of mind.

Assessment is responsive to expanded notions of intelligence[8] and creativity.

While many art educators already teach in ways that address multiple intelligences, few have developed strategies for assessing art learning through these various modes. Expanded concepts of intelligence, such as Howard Gardner's model of eight different intelligences, have potential for improving both instruction and assessment.

Creativity has reemerged as a topic of interest in cognitive psychology.[9] In the past, creativity was often measured by conducting superficial experiments testing fluency and novelty (i.e., how many things can be made from a paper clip and a rubber band?). The results of recent research focus on analyzing mental operations and characteristics unique to creative individuals. In keeping with the latest thinking about the subject, classroom assessments should address creative behaviors as they relate significantly to the art-making process.

Assessment is concerned with students' preconceptions and misconceptions.

Preconceptions significantly impact the learning process. They determine what will be understood during the course of an art lesson or program. Many times, students fail to learn something new because their prior knowledge is faulty or biased. In order for the art educator to build on students' prior knowledge and mediate appropriate instruction, information needs to be gathered concerning what misconceptions and preconceptions students currently hold. Such information can be gleaned from *preassessments,* assessments implemented before an art program begins.

Assessment is equal for all.

Classroom assessments are crafted to ensure fairness for all students. Equity issues art educators need to address include assessment content versus students' learning experiences, racial or sexist content of assessment tools, special adaptations of assessments for non-English speaking and intellectually- and physically-challenged students, assessment atmosphere and conditions that might influence outcomes, and proper interpretation of assessment scores.

Assessment Hint

For an easy and manageable way to begin, try responding to just one or two of these assessment principles during a given school year.

1.2 Australian high-school students taking an examination of core thinking skills which cross curricular subjects, Queensland, Australia. Photo: Donna Kay Beattie.

Assessment is standards-based.

Carefully crafted classroom assessments provide valuable information regarding to what extent students are meeting state and national content standards in the visual arts. Art educators should provide students with written examples of achievement levels regarding content standards as well as a library of exemplars they can use to self-evaluate and modify their performances.

Assessment is criterion-referenced and compares students' performances to past performances.

When students are compared with each other it becomes difficult to measure individual growth. *Criterion-referencing* addresses this problem by providing a type of score referencing system that compares students' work to a standard and/or to past performances.

Assessment is responsive to collaborative and cooperative learning.

Art instruction is largely a collaborative effort between teacher and student, as well as between students. Much of what students do in a typical art education program is done in cooperation with others. Strong evidence of learning in aesthetics, for example, is found in class discussions, debates, or group dialogues. In the art-making process, teacher and student both actively participate in decision-making, and students frequently help each other rethink and rework images. In effective assessments, collaboration proves a useful tool for setting assessment tasks, assessment criteria, and assessment standards, as well as for discussing ongoing tasks and redirecting if necessary. In addition, classroom assessments reveal the nature and significance of collaborative and cooperative learning.

Assessment allows for reserved judgment.

When appropriate, judgments concerning the correctness of student responses to assessment tasks can be decided after the response has been made rather than against a predetermined "correct" response.[10]

The teacher also might allow some assessment criteria to emerge as the task is being performed. Such practices encourage unexpected ideas and give students an opportunity to reevaluate their final scores and to offer valid reasons for responses that have been judged incorrect.[11]

Assessment is explicit and ordered.

Assessment directions, introductory materials, questions, and tasks are clearly worded, well-ordered, and in quality print. Easier tasks or items precede those that are more difficult. Questions grouped in clusters or blocks, each of which focuses on a particular topic, are preferable to one question per topic. Whenever possible, several images or examples are used to help students understand and compare ideas. Well-designed assessments provide students with information about the time of the assessment; special conditions and procedures; content to be covered; type of performance expected; how the performance will be judged, scored, and weighted; and the possible ramifications of performance results.[12]

Assessment exemplifies the latest and best assessment techniques.

Quality art assessment responds to new techniques being developed with respect to assessing cognition and instruction across the academic disciplines. Such responsiveness includes a willingness to examine large-scale testing and standardized models worldwide and evaluate how they might contribute to classroom programs. The school and classroom need to identify problems in student performance as revealed by state or national assessments and follow up with contextualized and individualized assessments for remediation purposes. Art educators, intent on improving their assessment programs, should learn as much as they can about different assessment strategies, including computer applications, and demonstrate flexibility by using a wide variety of assessment instruments, altering the strategies and weighting criteria for certain students, as needed.

Beginning Assessment

Like educators in other disciplines, the art educator is responsible for systematically providing information related to student learning to students, parents, schools, and school systems. Because art education lacks a significant history in testing, art educators have had to rely on their own teacher-constructed assessment techniques as a means of acquiring information related to student learning. The result has been, for the most part, quality assessment practices and strategies that take as their starting point the student as artist in the creating process. Such traditional art assessment strategies have emphasized *multiple validations* (assessments made over time), relied on qualitative information about both process and product, included personal judgments, made use of tacit knowledge, and compared students' outcomes to past performances.

More, however, is required of today's art educators. Increasing demands for more highly effective instruction and evaluation of complex cognitive processes have necessitated the implementation of new and improved models of assessment. These new models will enable art teachers to gather the data they need to report all the many different types and levels of information sought by students, parents, schools, and school systems. Additionally, and perhaps more importantly, these new assessment models can vastly improve the quality of classroom instruction. In other words, they are effective teaching and learning strategies as well as assessment tools.

The more high-stakes the assessment, the more precise its preparation becomes. An *assessment guideline* provides a structured step-by-step method for preparing and implementing an assessment as

well as ensuring that it is *valid* (appropriate for inter-preting results) and *reliable* (consistent in scoring results). The guideline proposed in this text and explained in detail in Chapter 7 (see page 115) consists of six major components that need to be clarified as the assessment is planned:

1 Purpose of the assessment
2 Domain to be assessed
3 Assessment strategy or task
4 Actual task exercises
5 Scoring plan
6 Reporting-out plan

This text provides the information the art educator needs to develop an assessment guideline and implement both classroom and high-stakes assessments. Specifically, the text will explain types of assessment strategies, including traditional and performance-based assessment strategies, with examples; methods for scoring and judging various assessments, how to implement both formative and summative assessment strategies, with examples; the Art Assessment Guideline; and a brief overview of major psycho-metric issues.

The importance of assessment on education and educational reform cannot be over-emphasized. Assessment initiates change in that it evaluates student progress and points out areas in need of improvement. Assessment helps define educational reform in that reform principles are stated in terms of the learning objectives that are measured by various assessment tools. And finally, assessment evaluates the success or failure of educational reforms, thus returning full circle to begin its role as initiator of change.

Notes

1 R.J. Stiggins and N.F. Conklin, *In Teacher's Hands: Investigating the Practice of Classroom Assessment* (Albany: SUNY Press, 1992). See also R.J. Shavelson and P. Stern, "Research on Teachers' Pedagogical Thoughts, Judgments, Decisions, and Behavior," *Review of Educational Research* 51: no. 4 (1981): 455–498. Shavelson and Stern report that teachers make decisions about students every two to three minutes.

2 A.J. Nitko, *Educational Tests and Measurement: An Introduction* (New York: Harcourt Brace Jovanovich, Inc., 1983). The first major assessment implemented in the United States took place in 1837 when Horace Mann called for oral and written teacher competency examinations. China, the pre-Qin Dynasty, is the birthplace of all testing, assessment, and evaluation practices.

3 A.J. Nitko, *Educational Assessment of Students*, 2d ed. (Englewood Cliffs, NJ: Charles E. Merrill Publishing Co., 1996) p. 21.

4 R.D. Sadler, "Specifying and Promulgating Achievement Standards," *Oxford Review of Education* 13: no. 2 (1987): 191–209. A comprehensive text of tests and measurement.

5 R.J. Marzano, D. Pickering, and J. McTighe, *Assessing Student Outcomes: Using the Dimensions of Learning Model* (Alexandria, VA: Association for Supervision and Curriculum Development, 1993) p. 19. This book identifies dimensions of learning and provides performance-based examples of ways to assess and score these dimensions.

6 The reflective domain refers to fields in which a subject, object, idea, or purpose is studied with the aim of understanding or accepting it, or of seeing it in its right relations. Art History, Art Criticism, and Aesthetics are part of the reflective domain. In the 1997 NAEP Arts Assessment, the reflective domain is referred to as "responding." Internationally, the domain is also described as "appraising." By contrast, the productive domain refers to fields in which a product is produced. In the NAEP Assessment, the productive domain is referred to as "creating." Internationally, the productive domain is also described as "making."

7 For purposes of ease and simplicity, the word "disci-
 pline," as used in this text, refers to discipline-based art
 education, that is, art education as comprised of the
 four disciplines of art history, aesthetics, art criticism,
 and art production. Please note, however, that while art
 history and aesthetics are universally considered genuine
 academic disciplines, many view art criticism, as, at most,
 a quazi discipline, and art production as not a discipline
 at all.

8 Using expanded and complex theories to describe intel-
 ligence has replaced the monolithic view of intelligence.
 See R.J. Sternberg, *Beyond IQ: A Triarchic Theory of
 Human Intelligence* (New York: Cambridge University
 Press, 1985). Sternberg has developed a theory based on
 a triarchic model that includes: (1) components of intel-
 ligence, (2) relationship of intelligence to experience,
 and (3) relationship of intelligence to the external
 world. See also H. Gardner, *Frames of Mind: The Theory
 of Multiple Intelligences* (New York: Basic Books, 1983).
 Gardner's theory of multiple intelligences is widely
 accepted and used.

9 See R.J. Sternberg, *The Nature of Creativity:
 Contemporary Psychological Perspectives* (New York:
 Cambridge University Press, 1988). See also two recent
 books which have explored creativity extensively, D.H.
 Feldman, M. Csikszentmihalyi, and H. Gardner, *Changing
 the World: A Framework for the Study of Creativity*
 (Westport, CT: Praeger Publishers, 1994), and M.
 Csikszentmihalyi, *Creativity* (New York: HarperCollins
 Publishers, Inc., 1996). It is well worth noting that
 despite all of the interest and attention given to the
 topic, the field of tests and measurement has still not
 been able to measure it adequately in tests of whatever
 type. See R.J. Sternberg, "Toward Better Intelligence
 Tests," in *Testing and Cognition*, eds. M.C. Witrock and
 E.L. Baker (Englewood Cliffs, NJ: Prentice-Hall, Inc., 1991).

10 C.M. Myford and R.J. Mislevy, *Monitoring and Improving
 a Portfolio Assessment System* (Princeton: Educational
 Testing Service, 1995) p. 2. One of the distinguishing
 features of performance assessments is that judgment
 about the correctness of a response is withheld until
 after the response is made. In other words, students'
 responses are not "simply and unambiguously classified
 as right or wrong."

11 G.P. Wiggins, *Assessing Student Performance* (San
 Francisco: Jossey-Bass, Inc. Publishers, 1993).

12 See note 3 above.

Chapter

2

Performance Assessment Strategies

The room is small, crowded, but orderly. Counters are laden with students' clay pieces which spill over onto the floor in the corner. Walls are covered with artworks, colorful posters, and teaching materials. The tiny adjoining room is bulging with art supplies on shelves and in cupboards. File cabinets are filled with resource materials. Steve White, elementary art specialist for Cooper Elementary School, surveys his domain with a sigh.

"How can I possibly have my students create portfolios? I teach 700 students a week. Where will I store 700 portfolios?" Mr. White believes in the potential of portfolios and journals, but implementing them seems impossible.

"I know there are wonderful things I might do in assessment, but by the time the students get all their materials out and then clean up, there is hardly enough time for me to teach and for them to work, let alone spend time assessing. Is it possible for portfolios to do it all?"

The problems faced by Steve White are shared by many elementary art specialists. Making time to assess in meaningful ways appears overwhelming. Like other art educators, Mr. White knows that art must also be held accountable for student learning, and he feels increasing pressure and need to improve upon his current assessment practices.

Distinction Among Types

Designing and implementing quality assessments take time and effort. They demand that the art educator has acquired a keen working knowledge of technical evaluation and assessment skills—a daunting task in itself. The rule of "learning by doing," adopted by the Ministry of Education in Israel to guide teachers as they develop school-based assessments,[1] can be applied to creating and implementing art assessment programs in America as well. The art teacher must be willing to learn by trial and error. "Such informed experimentation will enable the art educator to create assessment strategies that encourage students' best performances," writes British education expert Caroline Gipps. "Such assessment is time-consuming; we need to accept this and see it as part of the teaching process. There are no simple and cheap answers if we wish to have good quality assessment, and there never have been."[2]

Most art assessment strategies currently used by art educators are *performance-based*, which means a performance manifesting different kinds of knowledge and processes and multiple ways of reporting results. *Performance assessment strategy* is the term that refers to the task, method, or activity used to assess the performance in which students demonstrate their achievement and learning. Performance-based assessments can be designed in formats that require students to develop a process, a product, or both. A good performance task allows for the assess-

ment of many dimensions of student learning and complex cognitive processes. Although the task is performed for the primary purpose of evaluation, in many performance strategies new learning also figures as an important component. Numerous exercises may be required for students to complete a single complex performance task. Examples of performance-based assessment tools and strategies follow.

Performance Assessment Strategies
- portfolios
- journals, diaries, logs
- integrated performances
- group discussions
- exhibitions
- audio tapes and video tapes
- computers

Portfolios

In the past, the student art portfolio was viewed as a container for, or collection of, student artworks or products. More recently, as the art portfolio is increasingly used as a means of understanding and revealing processes, its definition has expanded to include a "purposeful collection of student work that tells the story of the student's efforts, progress, or achievement in (a) given area(s)".[3]

Whether referred to generally as the "art portfolio," or more specifically as the "process folio," "mini-portfolio,"[4] and "best-works portfolio,"[5] the portfolio as used in the art classroom today emphasizes *significant* evidence about the progress, achievements, and experiences of the student. The art portfolio, in its expanded definition, can replace other types of assessments and function as a teaching tool as well in that it motivates and challenges students, promotes learning through reflection and

Terms to Know

best-works portfolio Includes only students' best work, accumulated over a specified time period.

expanded art portfolio A thick base of information representing rich qualitative and ample quantitative evidence pertaining to a wide variety of thinking processes and art products.

mini-portfolio An abbreviated portfolio that focuses on a collection of art products based on a single theme, project, or artistic activity; a collection of evidence derived from a holistic task that addresses each of the four art disciplines; or a single unit of study. Several mini-portfolios can serve as the basis for a larger portfolio.

process folio A portfolio of evidence about student growth and learning, with an emphasis on process.

self-assessment, encourages student-teacher collaborations, validates different learning styles and approaches, and encourages the research, resolution, and communication of ideas. The art portfolio underscores to both students and parents the importance of growth and development. Finally, the portfolio provides an important tool for evaluating the curriculum and determining necessary changes.

Evidence

The earmark of a good art portfolio is its depth, regardless of the amount of time it spans. To be used as a performance assessment tool, the art portfolio should:
- specify the goals of the school, program, or student in a letter of introduction by the student.
- reveal evidence about learning in the four disciplines including knowledge of content, processes,

Terms to Know

extrinsic evidence Evidence of student learning outside of school. Examples include students' hobbies, interests, art museum experiences, art programs or lessons from other institutions, and certificates, awards, and achievements relative to art education.

maximum performance assessments Assessments designed to evaluate students at their best. An achievement test is an example.

primary evidence Visual, written, and oral evidence—actual student artwork, documents, and supportive materials. Examples include: art objects, photographs/slides of student artworks, notes, sketches, studies, drafts, written work, audio tapes, video tapes, and journals.

secondary evidence Reflections, interpretations, or judgments concerning the student at work or the product per se. The teacher's observation notes, logs, anecdotal records, evaluative reports, quizzes, student report cards, and students' self-assessments are examples.

typical performance assessments Assessments designed to evaluate students' typical or ordinary behavior.

conditions (or why certain processes are more appropriate), metacognition, art motor skills, and values, attitudes, and interests.

- reveal three kinds of physical evidence: primary, secondary, and extrinsic.[6]
- reveal a complete picture of and relate to specific goals of the art curriculum, a unit of study, or a specific discipline area.
- show progress over time.
- show significant achievements. A "best piece" can be specified with a note of explanation.
- reveal learning difficulties.
- reveal what is significant to the student.
- involve the student in the process of selection, reflection, and justification.
- include didactic information, (i.e., materials annotated by the student and/or teacher to include dates, explanations relating evidence to assignments and objectives, and reasons for inclusion).
- reflect adherence to performance standards.

In addition to such evidence, the art portfolio might also include a table of contents or outline of portfolio organization, a timeline of due dates for required entries, an exit letter describing major entries and reflection on learning outcomes, and a skills chart in which students indicate skills emphasized in specific entries or in the entire portfolio. A scoring rubric describing performance criteria and qualifying standards can be included in the portfolio. Charts 2 and 3 (see pages 133–137) are possible examples. A statement explaining how performance standards are translated into exit levels of achievement might also be added to the portfolio. Assessment Strategy 1 shows a sample checklist of evidence the art educator might require for student portfolios.

Student Checklist for Portfolio Evidence

Please place a check beside all evidence that you have included in your portfolio.

1 Include in your portfolio two letters to the teacher.
☐ introductory letter explaining your portfolio, your main purpose for creating it, and your goals pertaining to it
☐ exit letter describing major entries and reflecting on your learning outcomes in modes of thinking related to the artist, art historian, critic, and aesthetician

2 Include a Table of Contents or outline of the organization of the portfolio.
☐ Table of Contents

3 Include in your portfolio all materials that relate to solving your assigned problem(s).
☐ notes on the way you think about the problem, your interpretation of it, and how your thinking has changed
☐ "brainstorming" ideas for solving the problem
☐ research materials and sources that helped you solve the problem(s) or gave you insights or hints about what direction to pursue

☐ notes on the way you solve problems (i.e., your personal artistic problem-solving process)
☐ sketches, studies, or rough drafts that helped you practice and/or determine the solution(s) to the problem(s)

4 Include in your portfolio your final product(s) and specific materials that relate to it.
☐ final product(s) or visual evidence of it
☐ brief self-evaluation statement and judgment or scoring of the process that you went through to arrive at the final work piece(s)
☐ brief self-evaluation statement and judgment or scoring of the final work piece(s)
☐ brief argument (oral or written form), supporting your judgment of your portfolio. Your argument should take into account the total situation and the above-stated guidelines. Present your main points clearly and include reasons and rebuttals for anticipated challenges.
☐ brief description of your commitment and attitude toward creating the portfolio

Evaluation

Because of their breadth, depth of content, and amenability to diverse reviewing and assessing techniques, portfolios offer a wealth of multi-layered information about student learning. Portfolios reveal students in both *maximum* and *typical performance*

postures and, for this reason, serve in both summative and formative assessment roles.

Three scoring approaches are applicable to portfolio evaluation: *holistic*, *analytic*, and *modified holistic*. The teacher might use the holistic approach to score the portfolio if he or she is not interested in

the separate entries but in the portfolio as a single example of student performance—or, if time does not permit separate scoring of key individual entries. If the portfolio is a summative examination of students' abilities to produce a body of work on their own based on a theme, or is a mini-portfolio focusing on a unit of study, then the holistic approach is also appropriate.

A holistic approach judges, rates, or scores the entire portfolio as a single corpus of information. The following assessment criteria can be used to score the art portfolio holistically.

Researching:

- selection and development of themes, problems, issues, techniques, and processes through study, research, or exploration
- variety of appropriate sources

Creating:

- personalized and expressive approach to the area of study (i.e., art history, criticism, aesthetics, or art production)
- conceptual importance
- intellectual and creative curiosity driving art study and work
- demonstration of knowledge and skills pertaining to visual language, structures, forms, and vocabulary

Responding:

- responsiveness to personal, social, cultural, historical, philosophical, technological, environmental,

economic, and aesthetic contexts and stimuli in the area of study
- demonstration of description, classification, analysis, interpretation, and judgment of information and art images
- responsiveness to feedback
- depth of revision

Resolving:

- personalized and expressive solutions to problems or tasks in area of study
- completeness of collection (depth and breadth of entries)
- achievement of predetermined goals and objectives (student's, teacher's, school's)
- improvement from past performances

Communicating:

- presentation
- demonstration of self-reflection and self-assessment
- connection to other content areas and to daily life

When the portfolio is perceived as a repository of different types of knowledge, each requiring its own mark, then an analytic scoring approach is preferred. This approach evaluates and scores parts or characteristics of the product or process separately. For example, a teacher might give a separate score for the art history component, the art studio process, and the metacognitive skills of reflection. Each of the above-stated holistic criteria could be defined with degrees of quality, given a separate score, and then summed to obtain a single score. Cognitive processes, discipline-specific processes, and basic core skills also might be set up as criteria, examined, and rated.

See Charts 2 and 3 (pages 133–137) for examples of a holistic and an analytic scoring rubric based on the preceding assessment criteria.

Assessment Hint

The art portfolio is always evaluated. Although review and reflection are an ongoing process, specific times should be set aside for judging or scoring processes. Portfolios can also be discussed informally with other students via small group critiques.

The analytical scoring approach to portfolio evaluation need not exclude a holistic score. If the teacher wants discrete information about various areas of art learning, but also wants an overall or global score, then the modified holistic approach is best. A *modified holistic scoring approach* combines both scoring plans by scoring the whole first and then several major individual parts or attributes that support the global score. When combining both scoring plans, neither the holistic nor the analytic component is usually as detailed or comprehensive as each is when used independently.

Whatever approach art educators choose, portfolio evaluation utilizes a variety of assessment and scoring and judging strategies, such as checklists; rating scales; questionnaires; teacher, peer, parent, and other interviews; and student self-assessments. Different types of assessment strategies yield different kinds and levels of information. Assessment strategies, along with performance criteria and judging or scoring strategies, should be clearly understood by all involved. Ideally, evaluation should provide supportive information for judgments made by the art educator and enable the art educator to make needed changes in teaching and instruction. Evaluation should be documented in progress charts.

Interpretation

When the portfolio has been evaluated, the results need to be interpreted. Beyond a score or grade, the teacher determines what the portfolio really says about student learning, as individuals and as a class; the effectiveness of the curriculum; and the learning environment. The portfolio helps teachers address crucial questions about these three topics.

For a more meaningful interpretation of the portfolio, teachers might want to consider the following:

- To what extent have students' needs been met?
- What new needs have emerged for the students?
- Where will students go from here?
- What do the portfolios say about the classroom context? The learning environment? The art curriculum?
- What other kinds of information are revealed? Unexpected information?
- What evidence should be retained? What evidence might go to the next teacher?

Assessment Hint

After answering these questions, write a summary or, even better, a personal letter to the student that describes what you discovered. The summary or personal letter can be placed in the student's portfolio.

Terms to Know

analytic scoring rubric A scoring guide that scores individual parts or attributes of the product or process separately.

holistic scoring rubric A scoring guide that examines the product or process as a whole, rather than scoring individual parts separately.[7] Holistic scoring rubrics tend to provide a qualitative description of achievement levels.

modified holistic rubric A scoring guide that scores the whole first and then several major individual parts or attributes of the portfolio, product or process.

scoring rubric A scoring guide or formal plan for scoring a product or process.

Management

One of the most crucial issues the art teacher faces is managing the portfolios. Start by thinking about the design of the portfolio container. Will the portfolio container be large folded or stapled sheets of cardboard? A box? The computer?

What about storage? Where the portfolios will be stored is a major consideration (and problem) for the art educator. For storing large portfolios, consider cupboards or shelving accessible to students. If the portfolio will be used to examine students' abilities to produce a body of work independently within a specified time period, or, if it contains secondary evidence such as the teacher's observation notes, logs, evaluative reports, quizzes, assessment formats, or report cards, then security is crucial, and such portfolios would need to be kept in locked spaces.

How and when will the portfolio be integrated with instruction? How will portfolios be managed and monitored in a classroom setting? How will portfolios be shared? Classroom time should be periodically set aside for students and teachers to organize and work on the emerging portfolios. Blocks of time are also required for reviewing and evaluating portfolios. Moreover, the art educator needs time to develop, implement, monitor, and make changes and revisions in the entire portfolio management system. Finally, procedures for sharing portfolios with parents, other teachers, other students, and other stakeholders also need to be planned and executed.

Certainly, the art teacher of 700 students will have to create a portfolio style and management system that accommodates so many children. The portfolio may be conceived differently, as a smaller corpus of information—a *mini-portfolio*.

The Mini-Portfolio

The mini-portfolio can be likened to a thick file containing all manner of materials relating to the file's label. An easy way for students to organize their art learning, the mini-portfolio sorts the art curriculum into bite-size chunks. Because of its brevity and documentary nature, the mini-portfolio can be used to collect evidence representing each of the four art disciplines as demonstrated in a single integrated task or a unit of study.

The mini-portfolio might be a collection of art products, with supporting procedural evidence and materials, based on a theme or an art activity. As such, the mini-portfolio might be used to assess how well students can set a personal theme and develop a body of work independent of the teacher or in some degree of collaboration with the teacher. The smaller portfolio could also be used to examine skills and processes specific to one particular unit of study. For the elementary teacher of art whose curricula may be organized around many units of study, the mini-portfolio works well for documenting each unit.

The mini-portfolio maintains characteristics of the expanded portfolio in that it contains all significant evidence of a performance, performance criteria and a scoring rubric, skills chart, places to enter grades or marks, and a progress chart. Yet, it remains manageable and relatively simple to monitor. The mini-portfolio is simple to create, using lightweight tag board or construction paper, and is easily stored. Using the mini-portfolio enables students to take less significant work home during the course or school year, while retaining in the school setting benchmark works in each discipline to serve as the basis of a best-works portfolio. Finally, the mini-portfolio can be assessed and scored using holistic, analytic, or modified holistic scoring approaches.

Journals, Diaries, Logs

Journals, diaries, and logs are written and visual records of students' ideas, reflections, experiences, explorations, notes, studies, replies to teacher's questions, and statements on goals and objectives. Student journals are useful in all four visual arts disciplines as both teaching and assessing tools. A sketchbook used as the journal encourages exploration and the practice of media and techniques in art production. The art journal also serves as a tool for clarifying thinking processes, guiding research and other work processes in the reflective disciplines, and evaluating these processes and the final products. By dividing the journal page with a vertical line, students can use one

Assessment Hint

Be careful that the time requirements you set for journal work neither overwhelm nor bore the students. Try, for example, setting a class-time requirement of the first five minutes of the art period.

2.1 *Brian Carter-Smith, grade 12,* Journal page, *1997. Oil pastel, 8 1/2 x 12" (21.6 x 30.5 cm). West High School, Salt Lake City.*

Note: Even young children can reflect periodically on their journal work, provided they are given simple and clear questions. Depending on the age and development of your students, you might ask them to answer only some of the questions listed below.

Examples of cognitive processes and core skills possible to assess are bracketed.

Please answer briefly the following questions about your journal work.

1 Do your entries reveal your personal strategies for thinking and learning and solving a problem? Explain. [Cognitive processes: structuring and organizing information, and elaborating information by using mental and symbolic images]

2 Do your entries show research and study of a task or problem? Explain. [Core skills: searching and locating items/information, and generalizing from information]

3 Do your entries show evidence of personal, social, cultural, ethnic, or religious influences and relationships to the task or problem? Explain. [Cognitive processes: thinking in intrapersonal ways, and using prior knowledge to understand new information]

4 Do your entries show a progression of ideas? Explain. [Cognitive processes: knowing what kinds of goals to set, establishing goals, and determining if they are met]

5 What entry, in particular, represents a significant change in direction or thinking? Explain. [Cognitive processes: modifying practices, and reflecting]

6 Where might your journal be weak in evidence of your work? Where is it deep or strong with evidence of your work? Give reasons. [Core skills: criticizing, and judging/evaluating]

7 Based on what you have presented in your journal, how have you grown as an artist (or writer or thinker)? [Cognitive processes: reflecting, and understanding one's own weaknesses and strengths]

8 Based on your journal entries, how would you describe your general attitudes toward learning about and valuing art? To answer this question think about your motivation to learn and when, and under what circumstances, you experienced anxiety, pride, and self-confidence. [Cognitive processes: attitudes toward learning, and generalizing from information]

side for entries and the other for reflection on those entries. Reflections can be personal or comments from peers, parents, or the teacher. A rough draft of art criticism might be written on the journal page, with room left for peers, parents, the teacher, or the student to respond to the draft. Through use of journals or diaries, students learn firsthand that the four disciplines are grounded in knowledge of processes and methods of inquiry as well as knowledge of content.

What Is the Student Art Journal?

The student art journal is a small artist's sketchbook, small enough to carry around easily and place in the portfolio for review. The journal contains both assigned and independent entries from art history, art criticism, aesthetics, and art production. Entries might include research about an assigned topic; exercises or studies of art techniques; sketches of ideas; descriptions of thinking and working processes; rough drafts of writing assignments; information gained from class critiques, written assignments, class notes, definitions, and explanations; questions, personal beliefs, thoughts, and responses to artworks, artists, art issues, or teacher questions; doodles, and drawings of images to remember; and other materials, such as pertinent art images and text from magazines and journals.

How Often Is the Journal Used?

Journal entries may be written daily or as directed by the teacher to suit and support his or her particular art program. Outside class writing should also be encouraged. All journal entries should be dated.

How Are Journals Assessed?

Suggest that students store their journals in classroom lockers. Journals may be taken home at any time, but should be in class with the student at all times. The teacher might try collecting journals weekly or at some other regular interval. Peers, parents, the teacher, and students themselves should all participate in the assessment process. Not every journal entry needs to be read or assessed. Specify with students what entries will be read and noted by the evaluator. About once a month, the teacher and student should confer about the journal, discussing the quality and progression of the student's work.

Journal entries can be reviewed and assessed using different techniques such as: checklists (check

Assessment Hint

Suggest that students code their journal entries with letters that correspond to what the entry represents. For example, entries that are studies or sketches could be labeled with an "S", reflections with an "R", teacher questions or probes with a "P", and student questions with a "Q". This strategy not only helps the teacher review the journal but also helps students categorize their entries.

off if entries are there); rating scales (degree of quality of entries); teacher, peer, parent, other interviews; and student self-assessments (about quality and progress). Use the criteria that follow as a guide for assessing journals:

- *content:* Journals must include all written assignments and examples of content previously mentioned, as appropriate to required tasks. Several independent entries should accompany each assigned major task.
- *development of ideas:* Journal entries should demonstrate a progression and evolution of thought and research.
- *craftsmanship:* Although every sketch, idea, or written entry need not be exact or complete, journal entries should be readable, executed with care, presented in an orderly manner, and dated.

Clear guidelines enable thoughtful journal planning. As a performance strategy, the carefully structured art journal used in combination with a student self-assessment tool that focuses on numerous thought processes (see Assessment Strategy 2), yields vast amounts of information and, like the portfolio, addresses many of the eighteen desired principles for art assessment listed in Chapter 1 (see page 6).

Assessment Hint

If you are a novice interested in creating appropriate integrated performance strategies, then seek the opinions of colleagues concerning the proposed task. If, after careful thought and crafting, you try the integrated performance in the classroom, the resulting evidence will yield valuable insight regarding its success or failure. At that point, adaptations or changes can be made for future use.

Assessment Hint

A good rule to use in judging the value of an integrated performance is this: If the content and processes (including thinking processes) of the integrated performance seem impossible to score or judge, then the strategy is probably not worthwhile.

Integrated Performances

Integrated performances combine learning about a topic and being assessed on those learning outcomes all within a single performance task. In essence, the task has both a learning and assessing component. Integrated performances can include authentic, alternative, and didactic assessment tasks and be as open-ended, innovative, and unusual as the art educator's imagination.

For an integrated performance, students are given a task description, instructions, aspects of the task to be assessed during or following the performance, and scoring criteria. Because integrated performance assessment tasks often blur the boundaries separating instruction and assessment, the art educator must be certain to communicate clearly-stated assessment criteria and scoring plans.

Advantages vs. Disadvantages

Used as assessment strategies, integrated performances can be exciting and thought-provoking. Many students enjoy learning and being assessed in a single performance. (Assessment Strategy 4 on page 26 is one example.)

Examples (see Chart 4 on pages 138–141)
Integrated Performances
- dramatizations, role-playing
- extended written projects
- novel written projects
- individualized student projects
- group projects
- simulations and contrived situations
- demonstrations
- experiments

Art and Other Values Skit

This strategy demonstrates the overlapping nature of teaching and assessing in integrated performance strategies. The goal is to teach students how different historical, economic, ethical, social, moral, religious, and ecological values may influence aesthetic values and to assess students' abilities to comprehend that concept and discuss it using sound reasons.

Prepare a class skit depicting a meeting at which the Contemporary Art Society selects an artwork to present as a gift to the Contemporary Museum of Art. Characters in your skit should include:

- board members of the Contemporary Art Society who will present a choice of possible artworks to the membership for discussion and a vote.
- a member who holds a strong belief about community and social issues.
- a member who is very concerned about morality in the community.
- a member with strong religious beliefs and values.
- a member who believes in the work ethic "the harder you work, the more successful you will be."
- a member who believes art should be purchased or collected as an investment.
- a disgruntled member disillusioned with all contemporary art who believes good art must stand the test of time (i.e., "the older it is, the better it is").
- a member who believes art should be valued purely for its aesthetic value.
- the membership at large who add other "pearls of wisdom" to the conversation.

Present sound arguments for your character's position, and as a group draw final conclusions regarding the event and values that relate to art. Board members' selections of contemporary artworks should spark considerable controversy and discussion. Scoring will be both analytic and holistic.

Individually, you will be graded analytically with separate scores for:

- your role in the skit (motivation, commitment, preparation of your character's role).
- your ability to give sound and convincing arguments for your character's position.
- your application of previously learned aesthetic issues or beliefs appropriate to your argument.
- your communication skills.

As a group, you will be graded holistically with a single score that embraces:

- your research efforts to prepare for the skit.
- your presentation of the actual skit (organization, flow, entertainment value).
- your ability to discover and present the major issues concerning the relationships among the historical, economical, ethical, social, moral, religious, and aesthetic values presented in your skit.
- your ability to summarize and solve the skit's problem.

In your journal, write an entry stating your personal opinion about the major aesthetic issues related to art and other values that you discovered while creating your skit. This journal entry will also be given a separate score.

Students know beforehand the outcomes of this performance and are given the criteria on which the performance will be assessed. The teacher looks for evidence of these criteria as the skit is being performed and judges or scores each with a prepared checklist, rating scale, or other scoring strategy. Numerous other cognitive processes and core skills can be culled out for assessment purposes in this performance task, such as:

- recalling and remembering
- translating from one form to another
- using vocabulary appropriate to a context (art)
- paraphrasing, creating analogies, making connections
- synthesizing
- creating/composing/devising
- recognizing what type of goals to set, establishing goals, and determining if they are met

Art-Historical Problems

This strategy provides examples of extended written projects that demonstrate students' abilities to carry out art-historical research to successful closure. Students at both elementary and secondary levels are capable of researching and presenting art history problems like the following, but at varying levels of depth and expertise. Younger students can work in pairs or teams to complete the task, with a group score given to each student for the team product. Collaborative effort and group cooperation could be set up as dimensions to assess along with the other criteria.

1 **Research an element or principle across several paintings or art movements.**
- Study movement as depicted in Baroque Art, Futurism, and Op Art.
- Study the palette of Caravaggio, Mondrian, and Purvis de Chavannes.

2 **Research how certain groups are depicted in an art movement.**
- Study the depiction of minorities in artworks during nineteenth-century Realism.
- Study the depiction of women in artworks in seventeenth-century Dutch paintings.

3 **Research how certain objects are depicted in various still-life paintings.**
- Study a particular flower (and its symbolism) in flower paintings.
- Study Chinese porcelains in still-life paintings of the Baroque period.

4 **Research a snippet of historical writing by an art historian.** (The teacher might collect an assortment of these quotes, ranging from simple to more complex statements. Consult art history texts or monographs of artists.) Suggest that students work independently, in pairs, or small groups and select one quote on which to base their research questions and conduct their art-historical inquiry.

Panofsky writes about St. Joseph in the right-hand wing of the Mérode Altarpiece by Robert Campin, also known as the Master of Flémalle: "For the time being, he is engaged in producing what I believe to be (on the strength of Vermeer's Milkmaid*) the perforated cover of a footstool intended to hold a warming pan."[8]*

How are the footstools in *Milkmaid* and the *Mérode Altarpiece* similar? Different? What does the footstool represent in both artworks? What other Netherlandish artworks depict a footstool? If not a footstool in the *Mérode Altarpiece*, then what might the object be?

The teacher should look for students' abilities to: (a) pose research question(s), (b) conduct research, (c) use adequate resource materials, (d) answer research questions sufficiently, (e) draw conclusions about findings, (f) present research in an interesting and readable format, and (g) illustrate the report with images, studies, or drawings. Possible core skills to assess include: interpreting the meaning of words and symbols; expounding a viewpoint; synthesizing and recognizing which goals to set, establishing goals, and determining if they are met.

2.2 *Robert Campin,* Mérode
Altarpiece (Triptych of the
Annunciation), *c. 1425–28. Oil on
wood, central panel 25 1/4 x 24 7/8"
(64.1 x 63.2 cm); each wing 25 3/8 x
10 3/4" (64.5 x 27.3 cm). The Met-
ropolitan Museum of Art, The
Cloisters Collection, 1956. (56.70).*

2.3 *Robert Campin,* Joseph in His
Workshop, *right wing without
frame of the Mérode Altarpiece
(Triptych of the Annunciation),
c. 1425–28. Oil on wood, 25 3/8 x
10 3/4" (64.5 x 27.3 cm). The Met-
ropolitan Museum of Art, The
Cloisters Collection, 1956. (56.70).*

2.4 *Jan Vermeer,* The Milkmaid,
*c. 1658–60. Oil on canvas, 18 x 16"
(45.7 x 40.6 cm). Rijksmuseum,
Amsterdam.*

Assessment Hint

Variations on Assessment Strategy 5 (right) include creating a postcard note for each student, who must respond to the note and is assessed on his or her ability to answer the questions correctly and sufficiently. Student-constructed postcards can be exchanged among the students for answering, with each student writing a postcard note and also answering one. Students may also answer their own postcard questions.

Integrated performances can promote learning that extends beyond the classroom or learning that the teacher may never have envisioned. Moreover, they encourage creative and open-ended responses and the chunking or synthesizing of knowledge, address different learning styles and intelligence modes, and enable the simultaneous assessment of cognitive and metacognitive processes.

Integrated performances can also be problematic. They must support assessment purposes and be well-matched to lesson objectives or learning targets. The performance should reveal the extent to which students have mastered what they are supposed to learn. Integrated performances take time, and the task should be worth the time required of students to prepare and complete it. Integrated performances demand careful crafting to ensure that *discipline content* (declarative knowledge), *discipline processes* (procedural knowledge), and at least one *cognitive process* (complex thinking) or one *metacognitive process* (reflective thinking) are evident in the performance activity. Some activities, while entertaining and fun, unfortunately have little real substance or assessment value.

Integrated performances demand careful judging and score crafting. Developing an appropriate and reliable scoring strategy can be difficult. In addition, integrated performances introduce validity problems of performance task use and resulting score use and interpretation. Although Chapter 8 provides a full discussion of validity issues, for our present purposes it is important to note and consider potential equity issues. All students, for example, may not have the same opportunity to perform at their maximum or typical levels; some students or cultural groups may lack the background or experience to complete a performance successfully.

The art educator needs to examine carefully each suggested integrated performance for its potential as a successful performance assessment strategy; that is, its appropriateness for assessment purposes. The elementary art specialist may wish to limit the scope and numbers of some performances as well as execute some examples as oral activities. Setup of written materials can be accomplished on the computer by using graphics and page-layout software, scanning images or downloading from the Internet, supplying appropriate text—or, by designing an original computer program. The sample integrated performances that follow have been crafted from examples listed in Chart 4 (see page 138).

Postcards to a Friend

Postcards to a Friend is an unusual written project that can be designed to assess content and processes in aesthetics or art history. Students' abilities to identify and interrelate major ideas, themes, issues, or theories; interpret the meaning of pictures and illustrations; and to extrapolate are possible assessment criteria.

Students select several postcard reproductions that have a relationship to the topic or subject studied. The teacher can also choose appropriate reproductions from which students make their selection. Students are asked to study the image and decide what is a major idea, issue, or theory relating to the content of aesthetics or art history as illustrated by the artwork. They write a note to the aesthetician (Phil for philosopher) or to the art historian (Arty) stating the central issue in a question format. Examples of two possible responses are given.

2.5 Piet Mondrian, Lelie, 1921. Watercolor on paper, 10 x 8" (25 x 19.5 cm). Haags Gemeentemuseum, The Hague. © Hudson and Kilby, Attorneys at Law, Essex, CT.

2.6 Wilhelm Leibl, Das Mieder, fragment. Oil on canvas. Wallraf-Richartz-Museum, Cologne.

Dear Arty,
Can you believe this flower was painted by Mondrian? Why is this flower painted so differently from the rest of his artworks? How do his flower paintings relate to the gridded geometric paintings for which he is most noted? Are they as highly valued as his well-known artworks? What is their intent?

> Your friend,
> (student's name)

Dear Phil and Arty,
I saw this painting in the museum. It's a fragment! Can fragments be art? What was the artist's intent with this piece? Are fragments as valuable as whole works? Wouldn't it be fun to finish? If someone finishes an artist's unfinished work, then whose artwork would it be? Are there other famous fragments displayed as art-works in museums? Is Leibl an important artist?

> Your friend,
> (student's name)

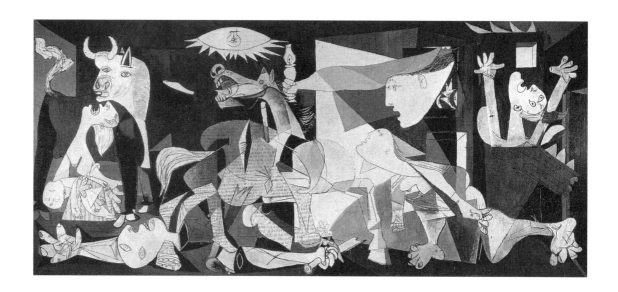

2.10 *Pablo Picasso, Guernica, 1937. Mural, approx. 11'6" x 25'8" (3.5 x 7.82 m). Centro de Arte Reina Sofía, Madrid. Photo: Art Resource, New York. © ARS, New York.*

Other Integrated Performance Strategies

Student-Constructed Performance Projects

This type of integrated performance strategy addresses current ideas concerning quality instruction. Specifically, a constructivist approach to learning in which students are encouraged to develop their own problems to solve will be discussed in some depth.

Many school-leaving or culminating high school art examinations given in Britain and Scotland encourage students to set their own final tasks. With input from the teacher, the student determines his or her own examination project and carries it out with relatively little intervention by the instructor. In a private girls' school in Edinburgh, for example, a student appliquéd and embroidered vintage menswear vests with exquisite flowers following study of Art Nouveau floral motifs. In The Netherlands, some students construct their final school-based examination projects around a single theme of their own choosing. None of these final performance projects, while selected by the students, are scored by them; the teacher, a team of teachers, or an outside examination board evaluates and scores the work.

1 Begin With Your Students' Interests.

Whether students write a research question, describe a problem, or propose an artwork, encourage them to start with an idea that really interests them. A musically-gifted art student to be assessed on the study and critical analysis of an artwork might ask: "If I could compose a musical score of *Guernica* by Picasso, based on the color, composition, mood, and interpretation of the painting, what would the music sound like? How could I best play it?"

Another student to be assessed in ceramics processes and skills might want to research the use of the figure in contemporary ceramics (see fig. 2.11) and create a series of figural ceramic pieces that combine social issues and fantasy. Whatever question, problem, or proposed series students choose, it should enable them to:

- demonstrate their existing knowledge about a subject.
- learn more about the subject.
- conduct independent research.
- engage in numerous processes related to art and thinking in general.
- produce a product.
- reflect on the entire process with written documentation.
- self-assess the process and product.

2 Next, Collaborate.

The teacher and student need to work together to identify the dimensions of the proposed task, which become assessment criteria for scoring the task collaboratively. The teacher and student construct three lists:

- a list of concepts, facts, or theories relating to content knowledge of the art discipline or domain involved in the task.
- a list of processes and skills related to the art discipline or domain of the task.

2.11 Janis Mars Wunderlich, Holding Their Children, *1996. Earthenware with glaze, 16 x 20 x 10" (40.6 x 50.8 x 25.4 cm). Collection of the artist.*

- a list of important core thinking skills and metacognitive processes involved in the task. From each list, the teacher and student together choose several as central to the task. These are then designated both as the learning targets and as the assessment criteria of the task.

3 Plan: The First Draft.

Students write a first draft of the proposed task. In the draft, they describe the question, problem, or proposed artwork(s) distinctly and precisely with stated objectives. At this point, the teacher and students work together to identify what research methods or techniques will be used to answer the question or create the proposed artwork and what strategies will be used for recording results.

4 Create a Scoring Rubric.

Teacher and students work together to write a personal scoring rubric for the task based on selected criteria identified in the second step. They also determine levels of achievement (achievement standards) on each criterion. Both processes and final product are included in the assessment scoring plan.

5 Plan: The Final Draft.

Students write a final draft of the task with all parts, including task description, objectives, methodology, assessment criteria, and scoring plan, clarified. The teacher approves the final plan.

6 Complete the Task and Self-Assess.

Students complete the task, following their personal guidelines. How much guidance the teacher gives during this stage depends on the purposes of the assessment. After completing the task, students self-assess their product and working processes as outlined in their personal assessment plan. All evidence can then be placed in a mini-portfolio.

7 Assess.

The teacher or outside juror now assesses the task as well. Negotiation between teacher and student determines the final assessment.

Similarities exist between the seven-step process for student-constructed performance projects outlined above and the nineteen steps of the Art Assessment Guideline designed for teachers (see page 115). The student process is greatly simplified because the projects originate with students and are designed for the purposes of students. As a result, many of the clarification steps outlined in the educator's model (Art Assessment Guideline) can be eliminated.

Assessment Hint

As part of the task procedure, suggest that students write a report summarizing their experience of the entire process.

Assessment Strategy 6

Model of a Museum Room

This strategy shows an example of an integrated performance from the category "Group Projects." In this example, students work cooperatively to solve a problem. The task provides opportunities for learning and didactic assessment of students' knowledge of art history content and methods of inquiry, aesthetics, art production, and components of art criticism.

Students work together in groups to create a model of an art museum. Each group assumes the position of an art historian who holds a particular philosophical stance about art which will, in turn, influence the kind of work he or she curates for the museum room.

A philosophical stance (for example, imitationalist, instrumentalist, feminist, institutional, or expressionist) is either selected by the group or drawn from an envelope. The art historian can also be a non-Western historian, and several multicultural beliefs about art can be included in the envelope.

A second possible dimension to add to this task is to have the group decide upon (or randomly draw) an approach to studying art, such as: specific artist, collection-related, mode or media, multicultural, thematic, stylistic, contextual, and so forth.

Using these different parameters, the group designs an appropriate model room to exhibit four or more small paintings they select for exhibition. Didactic labels and a taped or written exhibition guide that together justify the

selections and supply information about the art-works are also required.

Performance criteria for assessing the task are:

- application of aesthetic theory.
- use of art-historical inquiry approach.
- choice of appropriate artists or artworks.
- exhibition skills (framing, hanging, labeling).
- appropriate and creative design of space and room.
- substantial construction.
- the informative nature, creative format, and written or oral quality of didactic labels and materials.

Additional cognitive and core skills this project lends itself to assessing include: searching and locating information, interpreting the meaning of pictures or illustrations, criticizing and condensing written text, justifying, and visualizing.

2.7A Preservice elementary students' model of a museum room depicting Greek art (front view). Brigham Young University, Provo, UT, 1995. Photo: Donna Kay Beattie.

2.7B Preservice elementary students' model of a museum room depicting Greek art (inside view). Brigham Young University, Provo, UT, 1995. Photo: Donna Kay Beattie.

2.8 Preservice elementary students' model of a museum room depicting Japanese art (inside view). Brigham Young University, Provo, UT, 1995. Photo: Donna Kay Beattie.

Group Discussions

Viewed as a performance assessment strategy, the group discussion is a group demonstration task limited to one response mode—oral. Discussions provide insight about the class or group as a whole. In aesthetics and art criticism, the group discussion is treated as both an instructional and assessment strategy. Because of their collaborative nature, class discussions need to be carefully planned if they are used as a performance assessment tool.

Prior to the discussion session, consider establishing ground rules or dialogue models that encourage students to give reasons, respond to ideas and opinions of others, participate as equally as possible, and summarize ideas. Points to consider include:

- determining key issues or major points to be scored or judged.
- allowing important new ideas to emerge unexpectedly.
- preparing a scoring strategy for individual and/or group responses, such as checklists, tallies, rating scales, or anecdotal records (kept on note cards).
- devising strategies for enabling students to assess their own discussions.
- preparing a follow-up strategy as a way of assessing students' knowledge of the discussion topic, such as a final journal entry or summary report in which students respond to or interpret what happened in the discussion.

Assessment Hint

It may well be that the art educator will find it too difficult to score/record and facilitate the discussion simultaneously. In such a case, consider designating a facilitator. Be careful that the facilitator's task is clearly defined. For example, how much control will the facilitator exercise? How much input will the facilitator give?

Solve the Mystery

This strategy depicts another type of integrated performance, a Simulations and Contrived Situations *project. As students attempt to solve the mystery, they engage in art history inquiry. Learning objectives, both content and procedural, become embedded assessment criteria, which are determined at the same time the mystery is created.*

A wide range of thinking processes and skills can be examined, such as searching and locating information; interpreting the meaning of words or symbols; analogizing/making connections; grouping/ordering/categorizing information; seeking evidence and counterevidence; giving reasons; and presenting a position or argument. The teacher should look for evidence of each assessment criterion and check off its appearance or score its quality during the mystery simulation. Because steps or clues address different assessment criteria, a well-designed mystery should require that students complete each criterion successfully before moving on to the next step or clue.

The teacher crafts a mystery for the students to solve about the painting, The Fairy Feller's Master Stroke *and the artist, Richard Dadd. Clues about the painting and the artist might be left around the artroom, placed in certain art books, or delivered to the class by strange couriers. Audio tapes of secret "telephone conversations" can be played. Parts of the painting or life of the artist can be reenacted or video taped. Real objects, as depicted in the painting, can be brought to the class-*

room as evidence. Possible methods for presenting clues and evidence are countless. With just a little thought, you can design some unusual and captivating methods. The following sample "seeds" can be developed by the teacher into mystery clues, which help the students describe, analyze, interpret, and judge the artwork, the artist, and the context surrounding it.

- who is the Fairy Feller?
- what is a master stroke?
- what is being stroked?
- a murder is committed
- the words "large and small, near and far, major and minor"
- what prompted the painting?
- what flora are depicted?
- what is the importance of the grass?
- Titania
- someone is insane
- Lilliputian
- the words "escapist fantasy"
- an old poem about a grasshopper which can glimpse "fairy folk the stalks between"
- whose artwork is it?
- the term "bedlam"
- *Alice's Adventures in Wonderland*
- Oberon
- maniac
- the words "congested space"
- what is the size of the painting?
- the mental hospital Bethlehem[9]

2.9 *Richard Dadd,* The Fairy Feller's Master Stroke, *c. 1855–64. Oil on canvas, 21 1/4 x 15 1/2" (54 x 39.4 cm). Tate Gallery, London.*

Assessment Strategy 8

Discussion Rating Scale

Please circle the number that best indicates your judgment of each discussion-related item.

Numbers 1 through 5 correspond to various degree statements as shown.

How do you feel about today's class discussion?

1 Treatment of topic issues

1	2	3	4	5
(superficial)			(thorough and deep)	

2 Helpfulness of discussion to your own understanding

1	2	3	4	5
(low)				(high)

3 Your own level of participation

1	2	3	4	5
(low)				(high)

4 The class's overall level of participation

1	2	3	4	5
(low)				(high)

5 Quality of your own spoken remarks

1	2	3	4	5
(poor)				(excellent)

6 Quantity of your spoken remarks relative to your normal participation

1	2	3	4	5
(low)				(high)

7 Degree of your own understanding of the topic

1	2	3	4	5
(limited)				(full)

8 Facilitator's success

1	2	3	4	5
(too much input)			(too little input)	

1	2	3	4	5
(too much control)			(too little control)	

1	2	3	4	5
(too little respect for others)			(high respect for others)	

Assessment Strategy 8 shows an example of a ratings scale in which students rate the discussion session themselves. The teacher might also periodically fill out a simplified version of the ratings scale for each student and see to it that both student and teacher ratings are included in the student's portfolio.[10]

A final method for observing and assessing discussions is a sociogram observation chart. A diagram is drawn of responses with arrows indicating the sequence of speakers and numbers or letters for the students. The sociogram makes apparent who is and is not actively involved in the group discussion. From this strategy, the art educator can determine participation points or a score. Impressions regarding quality and effectiveness of students' spoken remarks can also be noted.

Exhibitions

Having students exhibit their work in both art production and art reflection (i.e., art history, art criticism, and aesthetics) can also be a performance assessment strategy. In addition to providing the opportunity to assess the quality of the assembled products, this strategy allows the art educator to examine other dimensions of student growth, such as:

- knowledge of theories, purposes, resources, organization, structure, and skills integral to mounting an art exhibition.
- individual and group goal-setting skills.
- problem-solving skills, such as abilities to identify, define, and represent a problem; explore different solutions; act on a final solution; and assess and reflect on the solution.
- technical (planning and construction) skills.
- interpersonal skills.
- both personal and group abilities to glean, interpret, and synthesize information from the

Reflections on the Art Exhibition

1 What are the purposes of art exhibitions? What kinds of works might be exhibited in an art exhibition? [Cognitive processes: recalling/remembering, generalizing from information]

2 What information did you need to know before you could set up an art exhibition and where did you find it? What problems did you need to solve before mounting the exhibit? How did you solve those problems? [Cognitive processes: applying strategies to trial and test ideas/procedures, and generalizing from information]

3 Did you set goals for the exhibition? Explain your group goals and your personal goals. How did you arrive at those goals? [Cognitive processes: recognizing which goals to set, establishing goals, and determining if they are met]

4 What was the biggest problem you faced *during* the actual setting up of the exhibition? How did you solve that problem? In retrospect, was your solution the best one? What might you do differently now for a second exhibition? [Cognitive processes: reflecting, and modifying practices]

5 What did you learn about working with a group during the development of the exhibition? How did you organize yourselves to accomplish the task? What personal qualities or personality traits needed to be exercised for the exhibition to succeed? [Cognitive process: recognizing underlying principles/structures]

6 What did the exhibition tell you about your own future direction in art? [Cognitive processes: extrapolating, and generalizing from information]

7 Was it a good exhibition? Would you have walked in off the street to view it, if you had seen a little of it through the window? Explain your reasons. [Cognitive processes: judging/evaluating, and expounding a viewpoint]

8 What would you tell a stranger about the art exhibition? A viewer who knows little about art? An art critic from the newspaper? [Cognitive process: explaining to others]

9 What was the most significant thing you learned from the exhibition? [Cognitive process: reflecting]

exhibit and judge its value.

- articulation and expression of ideas pertaining to
the exhibition to a diverse audience.
- students' abilities to understand on a personal
level what direction to pursue next with regard to
their own artwork.
- student attitudes, motivations, and commitment
toward the exhibition task.

The art educator might try using observations,
class discussions, a checklist, journal entries, student
self-assessment techniques, or a student question-
naire to assess these dimensions of student growth.
Assessment Strategy 9 provides a list of questions, in
a short-answer assessment format, which the art edu-
cator might use to gain information about what stu-
dents have learned. The elementary art specialist
may choose to select only a few of the questions for
a class discussion.

Audio Tapes and Video Tapes

The use of technology for assessment purposes is
rapidly changing the field of assessment. Video- and
audio-taped performances can be used in conjunc-
tion with portfolios, class discussions, any tasks set up
in an interview format, integrated performances,
and various scoring strategies such as student self-
evaluations and teacher or student critiques.

Computers

Computer-based portfolios are the design of the
future, but may not be time-savers or cost-savers.
The computer portfolio enables students to scan in
their artworks, create written entries, and reflect on
their works in a file that is accessible to both teachers
and parents. Computers can also be central to scoring
strategies such as student self-evaluations, critiques,
and various interview formats. In addition, today's

computer-wise students, working in teams, are able to demonstrate their knowledge of art concepts by developing computer programs.

The advantages of using a computer for assessment purposes are:

- maintenance of strict standardization.
- direct presentation of materials and stimuli to students.
- adaptive or tailored testing, whereby problems and tasks can be selected by students according to their ability level.
- instant feedback concerning right or wrong responses or choices.
- instant and accurate scoring.
- accurate record-keeping with multiple copies and easy transmission of results.

In short, the precision and "patience" of the computer make its use ideal for many assessment practices.

Performance-based vs. Other Assessment Strategies

The trend in general education is toward performance-based assessments. Although performance assessment strategies require careful thought and planning if they are to be effective, they are well worth the effort. Performance strategies exemplify excellent models of ideal processes, those that engage students in complex thinking skills and multi-level tasks.

Notes

1 D. Nevo, "Combining Internal and External Evaluation: A Case for School-Based Evaluation" *Studies in Educational Evaluation* 20: no. 1 (1994): pp. 87–98.

2 C. Gipps, "Developments in Educational Assessment: What Makes a Good Test?" *Assessment in Education: Principles, Policy, and Practice* 1: no. 3 (1994).

3 J.A. Arter, "Portfolios in Practice: What Is a Portfolio?" (paper presented at the annual meeting of the American Educational Research Association, San Francisco, CA, April 1992) ERIC, ED 346156.

4 D.K. Beattie, "The Mini-Portfolio: Locus of a Successful Performance Examination," *Art Education* 42: no. 2 (1994): pp. 14–18.

5 A.J. Nitko, *Educational Assessment of Students*, 2d ed. (Englewood Cliffs, NJ: Charles E. Merrill Publishing Co., 1996).

6 H.G. Mackintosh, "The Use of Portfolios in School-Based Assessment: Some Issues" (paper presented at the nineteenth annual conference of the International Association for Educational Assessment, Reduit, Mauritius, 1993).

7 See note 4 above.

8 E. Panofsky, *Early Netherlandish Painting*, vols. 1 and 2 (New York: Harper and Row, 1971).

9 R. Rosenblum and H.W. Janson, *Nineteenth Century Art* (Englewood Cliffs, NJ: Prentice-Hall, Inc., 1984).

10 G.P. Wiggins, *Assessing Student Performance* (San Francisco: Jossey-Bass, Inc. Publishers, 1993).

Chapter

3

Traditional Strategies: Tests, Questionnaires, and Visual Identification

"Can you believe the art history test Mrs. Ishii gave us?" muttered one of the high school students walking out of the Art I class. "I thought for sure it was going to be just another multiple choice. I even developed a pattern for answering the questions."

"I hate essay tests," moaned another student, "I have to know the material to be able to write an essay."

"Yeah," chimed in a third student, "everyone said I would do okay as long as I just memorized the dates of artworks."

The fourth student in the group, responding to her friends' comments, said, "Well, I thought it was a good test, because it made me think of new connections I hadn't thought about before, and we were able to write our own opinions about the artworks. I just hope she grades my opinions fairly."

Terms to Know

closed item Question or exercise that requires a specific and correct answer. A closed test item is not context-oriented and offers little opportunity for imagination, initiative, collaboration, or investigation.

constructed-response essay item An essay format that allows students to construct their own answers.

extended-answer essay item An essay format that enables students to write on many different dimensions of a problem or task.

item analysis Type of statistical analysis that examines student responses to test items for the purpose of making decisions about the soundness of the question.

item bias Type of statistical analysis that measures bias in test questions.

master list A key list of answer options.

open-ended item Question or exercise that allows students to answer by using any resources that may have bearing on the task.

pencil-and-paper test format Traditional test formats that elicit from students, by means of a series of questions that are often answered by filling in a bubble sheet, information concerning skills and concepts they have learned. Knowledge is generally described by a numerical scale.

short-answer format A format that through design and wording limits the length of students' answers.

standardized tests Emphasize like administrative and observational procedures, equipment and materials, and scoring rules in an effort to ensure that the exact testing format occurs regardless of when and where the test is given.

stem The part of the item that asks the question, states the problem, or sets the task.

test An instrument or systematic procedure for observing and describing a characteristic or behavior.

test item Question or exercise that appears on a test.

testing A data-collecting process for the purposes of evaluation.

Kyoka Ishii, the newest teacher in the art program, listened to her students' comments with interest. She was pleased that she had decided to use open-ended essay questions on her test. She was also proud of her ability to write questions that required the students to apply their knowledge in new ways and to form their own opinions with supporting reasons. Yet, she realized now that she could have done a better job preparing them beforehand for the test and how it would be marked. "Next time, there won't be any surprises," she vowed.

Familiar Question Types

A test is a type of evaluation format. A *test item* refers to the question or exercise or task appearing on the test. Common test item formats include multiple-choice, true-false, completion, matching, and essay questions. *Open-ended items* allow students to answer the question in a variety of ways while *closed items* require a specific, "correct" answer. Sometimes, test items are carefully analyzed by different statistical procedures for their bias (*item bias*) or for their soundness by examining students' responses to them (*item analysis*). These analyses are particularly important for *standardized* and large-scale testing practices.

Alternative Question Types

Other pencil-and-paper item formats described below can be used to assess numerous higher-level thinking skills. Assessment experts maintain that the way to assess students' higher-order and critical thinking skills is for them to use their knowledge and skills in new or novel situations.

Grid Questions

Grid questions are basically enhanced multiple-choice questions, with options (the given responses

or alternatives) displayed in a grid (see Assessment Strategy 10, page 44). Options can be verbal or visual images. For young children, the art educator might use line types or colors as options. Students select several options to answer numerous *stems*, that is, the part of the item that asks the question, states the problem, or sets the task. The advantage of a grid question is that a question, requiring more than one part for the correct answer, can be answered easily with options. Thus, grid questions provide the teacher with information about students' abilities to identify parts and their relationships. Abilities to recall/remember, interpret the meaning of words/symbols, and analogizing/making connections are examples of skills possible to assess using grid questions.

Identifying Instances Questions

Identifying instances questions are designed to assess students' abilities to identify examples or illustrations of a concept. In this type of test format students are given a *master list*, or key list of given options. The master list includes several concepts, each with assigned letters. Questions consist of examples, as well as non-examples, of the concepts. Students are then asked to select the appropriate examples of the concepts. The example shown in Assessment Strategy 11 on page 45 assesses students' comprehension of the institutional theory: "X is art if it is exhibited or sanctioned as an artwork by the art world" and the instrumentalist theory: "X is art if it serves as an instrument of truth about an important purpose or cause."[1] Although this sample test-item strategy does exactly what it is supposed to do—test knowledge acquisition of a concept—the assessment strategy could be strengthened by requiring students to support their responses with written reasons.

Tests

Along with performance-based tasks, the test is used extensively in the art classroom. Teacher-generated tests and quizzes are, in fact, the most commonly used assessment strategies in classrooms generally.

Tests have a long history of use in general education. They are relatively easy to construct, can be scored quickly and objectively, whereby scoring reliability is high, cover a wide range of content, and are not impeded by students' writing skills.

The three greatest disadvantages of most test strategies are their passiveness, their indirectness, and their diminished cognitive complexity. Students are not allowed to express what they know about a subject in an individual manner or be actively, personally, and creatively involved in the genuine characteristics, thought processes, or structure of a subject. Traditional test item varieties are one step removed from the reality and actual experience of a subject, and the further away, the less sound score interpretations are. Often test items are not well designed and as a result, they only assess lower-order cognitive skills such as recall or comprehension of terms, facts, dates, persons, or events.

Because tests have helped shape instruction in objectionable ways, they have been met with disdain and disapproval in the last decades. It is well to remember, however, that no assessment or test strategy is bad, but simply used inappropriately or constructed poorly.

Art History Grid Questions

Directions: The grid indicates various branches or approaches of major art-historical move-ments. Please select the appropriate branches for the following statements using the grid. Mark the correct letter(s).

A Action Painting	B Expressionist	C Analytic
D Illusionistic	E Color-field	F Automatist
G Formalist	H Hard-edge	I Synthetic

1 These represent the major artistic branches of Postimpressionism.

A C, F, I
B C, G
C A, E
D F, G, I
E D, F, H

2 These represent major artistic branches of Abstract Expressionism.

A C, D
B B, F, G
C C, H
D A, E, H
E A, C, E

A variation of identifying instances is color-coding instances. In this type of test format, students identify concepts, ideas, or theories in introductory material or lead-in information by color-coding them. For example, the teacher might give students an exam-ple of written art criticism and ask them to color code all instances of description in red, interpreta-tion in blue, and judgment in purple. The art educa-tor might then pose a follow-up question to help students summarize their findings: "Based on the results of your color coding, what conclusions can you draw from this example about the three major components of art criticism (description, interpreta-tion, judgment)?"

Producing Examples Questions
This test format requires that students produce new examples of a given concept. Students must give examples of the concept that are different from those presented in the stem. Assessment Strategy 11

Assessment Strategy 11

Institutional and Instrumentalist Theories Test

Directions: Please read the six different situations. Decide if they best represent an example of the institutional theory or the instrumentalist theory, both, or neither. Mark your decision with the appropriate letter.

A = Institutional Theory
B = Instrumentalist Theory
C = Both
D = Neither

_____1 A Native American rug is hung on the wall in an art museum.

_____2 A painting by Picasso depicts the atrocities of the Spanish Civil War.

_____3 An Islamic mosque lamp is critiqued in *ArtNews* Magazine.

_____4 A stack of tires is removed from a junk yard and installed in a science exhibit called "Stacks of Trash—An Environmental Issue."

_____5 McGraw-Hill published a book on Andy Warhol's collection of cookie jars.

_____6 One of Faith Ringgold's story quilts was purchased at a prestigious New York gallery and placed on a bed in the owner's guest bedroom.

(left), like Assessment Strategy 12, presents an appropriate format for assessing students' knowledge of the institutional and instrumentalist theories. Assessment Strategy 12, however, is stronger than Assessment Strategy 11 in that it can assess a wider range of student skills including recalling/remembering, explaining to others, and creating/composing/devising/inventing.

Linked Questions

This kind of test question, as the title suggests, is based on two linked questions. One variation entails a yes-no question followed by a linking question consisting of several options that might support the yes-no response. In the first question, students determine whether the stem of the item is right (yes) or wrong (no). Then, they select, from several options given in question two, reasons that support their judgment. *Linked questions* help students verify their initial yes-no response.

Web Questions

Web questions are presented in a format based on concept webbing or mapping. Students are asked to write open-ended responses around and pertaining to a central topic in the center of the web (see Assessment Strategy 13).

Assessment Hint

Ask students to write their own reasons for their responses to the yes-no questions discussed in Linked Questions.

Judging Credibility Questions

Relatively easy for the art educator to craft, this type of assessment (Assessment Strategy 14) reveals students' abilities to judge a credible statement, example, or argument and justify their judgment with reasons. Art criticism or art history writings offer excellent opportunities for students to judge the credibility of what, for example, the critic or art historian is saying about artworks.

Deeper Issues of a Problem Questions

This question type assesses how deeply students understand a problem. The problem-solving skills of students with limited expertise will focus on surface features and relationships rather than underlying principles or rules. *Deeper issues of a problem questions* assess students' ability to create an appropriate model for solving a problem.[2] Assessment Strategy 15 is based on a common art education task: sorting postcard art reproductions.

Assessment Hint

With young children, consider using judging credibility questions as the basis for a game. Modeled after a television panel show, one game provides students with several different good and underdetermined interpretations of an artwork. Students must decide which are most plausible and give reasons for their choices. If known, consider including the artist's original interpretation of the artwork, which is described in aesthetics terminology as the "correct" interpretation.

Assessment Hint

Justifying is an important thinking process that is left out of the example given in Assessment Strategy 12. Adding that skill, by having students explain their answers, would strengthen Assessment Strategy 12.

Assessment Strategy 12

Producing Other Examples of the Institutional and Instrumentalist Theories

Directions: Below are given one example each of the institutional and instrumentalist theories and one example in which both theories apply. Please write three examples of your own for each theory and three for a combination of both.

Institutional Theory: A Native American rug is hung on the wall in an art museum.
Three examples: _____

Instrumentalist Theory: A painting by Picasso depicts the atrocities of the Spanish Civil War.
Three examples: _____

Institutional and Instrumentalist Theories: One of Faith Ringgold's story quilts was purchased at a prestigious New York gallery and placed on a bed in the owner's guest bedroom.
Three examples: _____

Web Questions

The advantage of this question type is that it reveals how students organize and connect concepts, perceive patterns, generalize from information, and recognize processes for recalling information. Have students label their web connections with such words as "causes," "results in," "relates to," or "means" to help see their linkages.[3]

Assessment Hint

To score a web question, the teacher develops beforehand a master list of key concepts and then looks for their presence in students' webs. Because there is no single, "correct" way of linking ideas, students may well give other answers that deserve points (for example, demonstrating logical organization).

Good and Underdetermined Interpretations

An art image is presented as a slide or reproduction in concordance with an interpretation (Interpretation A) written by a critic or art historian. The teacher also creates an example of interpretation (Interpretation B) which cannot be substantiated by evidence in the artwork (an underdetermined interpretation) Students have to identify with an A or a B which interpretation is "good" and which is "underdetermined" and write reasons for their choices.

1. A Good Interpretation
Reasons why it is good:

2. An Underdetermined Interpretation
Reasons why it is underdetermined or cannot be supported:

To vary this strategy, the teacher might also present a blended example of good and underdetermined interpretation for students to sort out the parts that are credible and the parts that are not credible. Two very different but good interpretations or two very different but undetermined interpretations can also be lead-in material.

Sorting Deeper Issues

Give each student a set of approximately six varied postcard reproductions. Ask students to sort the postcards into categories based on deeper issues the artworks might suggest or exemplify. The teacher can suggest a few categories or leave the selection entirely up to students to create. Examples of possible categories include:

- formalist issues or rules and principles of composition, such as color, space, mass, or balance problems.
- social, gender, or religious issues; aesthetic concerns of a culture.
- philosophical issues, such as problems about the art object, the artist, the audience, or context surrounding the artwork.
- self-expressive issues and/or psychoanalytical issues relating to the artist.
- commercial issues, concerns of functional artworks.
- environmental issues, such as art versus natural or man-made environments.

As students identify their categories, they place each artwork into the appropriate category and justify their decisions with reasons. A matrix can also be created as the answer sheet. The teacher looks for evidence demonstrated in selection of categories and the placement of artworks within categories, and in students' abilities to identify the deeper issues that surround artworks when viewed as a group of images and artworks viewed as individual images. Additional assessment criteria addressed by this strategy include: comparing and contrasting, classifying, and recording and noting data.

Interpretive Questions

Set in various-type formats, *interpretative questions* require that students explain the meaning or significance of information. Students are given introductory material followed by a series of questions or tasks based on the material. A wide assortment of content material can be used as the interpretive stem, such as quotations from artists, art historians, and critics; images of artworks; and art-related stories or problems.

Assessment Strategy 16 focuses on understanding a single artwork, *Poorhouse Woman with Glass Bowl*, by Paula Modersohn-Becker. Because this strategy assesses students' thinking processes when confronted with new information, students do not need to have studied this particular artwork in advance. Each question provides increasingly sophisticated information about the artwork and assesses students' abilities to respond to more complex thinking skills. The questions are designed to correspond to the Quellmalz (1985) cognitive taxonomy: *recall, analysis, comparison, inference, and evaluation*.[4] Information in brackets indicates the skill being assessed.

Student-Generated Test Questions

The *student-generated test question* represents a unique category of test question types. In this type of test question, the student chooses the format that best addresses what he or she perceives as the content or skill most worthy of assessment. Students provide model answers for the questions they generate. The teacher allows students to include their individual questions as an item on a teacher-constructed test and gives points for the quality of both the question and answer.

Essays

Essays have the potential for yielding more information than most pencil-and-paper test strategies about why and how a student gets an answer right or wrong. Furthermore, essays lend themselves to assessing many cognitive processes, such as explaining, comparing, contrasting, analyzing, creating, synthesizing, and evaluating.

Essays are *constructed responses* (student constructs his or her own answer) and can be crafted in *short-* or *extended-answer* formats. Restricted-answer formats, through their design and wording, limit what students are able to answer. Extended-answer formats enable students to write on many different dimensions of a problem or task. An extended written task or project, such as an illustrated art-historical report, may also fall into the category of a performance assessment strategy or an integrated performance strategy as described in Chapter 2 (see pages 14, 24).

As an assessment strategy, the essay lends itself to judging a combination of skills. Essays, however, are

3.1 *Our Lady of Good Hope, 11th cent. Church of Notre-Dame, Dijon, France. © Arch. Phot. Paris/CNMHS. Artwork such as this may be used for making comparisons in* Block Questions, *as described in Assessment Strategy 16.*

not appropriate for assessing factual information exclusively. Assessment Strategy 17 on page 52 shows an example of an essay item in aesthetics appropriate for older students.

This sample essay task will lend itself to the assessment of many criteria, including students' knowledge of aesthetics content as demonstrated

Assessment Strategy 16

Block Questions

The Dutch use the block format extensively in their standardized state-mandated testing practices. A well-conceived block can assess a wide variety of thinking skills in a sequential and cohesive manner.

Question 1: This painting, titled *Poorhouse Woman with Glass Bowl*, was painted by Paula Modersohn-Becker in 1906. Describe three key features of the image and explain the significance of each to the work. [Cognitive processes: Describing subject matter, ranking]

Question 2: The glass bowl provides great interest to the work. How does it unify the composition? Describe three ways. [Cognitive processes: recalling/remembering, analyzing formal and expressive properties, perceiving patterns relating to the principle of unity]

Question 3: Old Dreebeen, the figure in the painting, was reportedly a strange woman whose remoteness, dialect, intonation, and capacity for telling stories in a trance-like manner captivated Modersohn-Becker.[5] Give three examples of how Modersohn-Becker created Old Dreebeen's mysterious appeal. [Cognitive processes: interpreting the meaning of words/symbols, analogizing/making connections, analyzing formal and expressive properties]

Question 4: The glass bowl has been referred to as a birdbath, to which the artist attached superstitious significance.[6] What evidence in the work supports this interpretation? [Cognitive processes: inferring, explaining to others, elaborating infor-

3.2 Paula Modersohn-Becker, Poorhouse Woman with Glass Bowl, 1906. Oil on canvas, 38 x 31 1/2" (96 x 80.2 cm). Sammlung Böttcherstrasse (Roselius-Haus mit Sammlung Paula Becker Modersohn, Wafensammlung u. Stiftung Ludwig Roselius Museum), Bremen, Germany.

mation by using mental or symbolic images, interpreting the meaning of pictures/illustrations]

Question 5: *Poorhouse Woman with Glass Bowl* has often been compared to van Gogh's *La Berceuse*, painted seventeen years earlier. Discuss three comparisons between the two works. [Cognitive processes: comparing and contrasting, analyzing subject matter and both formal and expressive properties]

Question 6: Modersohn-Becker was very interested in the figures, animals, and leaf work found in medieval cathedrals, stone sculpture, and capitals. Art historian Pauli compares *Poorhouse Woman with Glass Bowl* to medieval miniatures and Romanesque church sculptures.[7] Discuss two comparisons that can be made using figures 3.1 and 3.4. [Cognitive processes: comparing and contrasting, analyzing, translating from one form to another, justifying]

Question 7: Modersohn-Becker wrote in her diary, "I believe that one should not think too much about nature when painting, at least not during

3.4 *Flight into Egypt, narthex capital, c. 1004–30. Church of Saint-Benoît-sur-Loire, Fleury, near Orléans, France.*

3.3 *Vincent van Gogh, La Berceuse, 1889. Oil on canvas, 36 x 29" (92 x 73 cm). Rijksmuseum Kröller-Müller, Otterlo, The Netherlands.*

the painting's conception. The color sketch should be exactly as one has perceived things in nature. But personal feeling is the main thing."[8] Two different aesthetic theories are inferred in this quoted passage. Discuss the one theory that Modersohn-Becker seeks to emphasize most in her paintings. [Cognitive processes: interpreting the meaning of words/symbols, inferring, recalling/remembering]

Question 8: Reflect on your answers to all of the previous questions. By what criteria would you judge this artwork? Determine a set of three criteria appropriate for judging this painting and draw conclusions regarding the success of this artwork. [Cognitive processes: outlining and ranking, judging/evaluating, creating/composing/devising/inventing]

Assessment Hint

If students will be allowed to make revisions in their essays, then instructions might include: "a first draft of the essay (read and edited by a peer) and all background notes and research are required along with your final paper in an essay folder."

Assessment Hint

Remember to let students know ahead of time how their essays will be evaluated. Include in the description of the task you give to students, a list of criteria you will assess in their essays.

Assessment Strategy 17
Essay Question

Write an essay stating and explaining your own personal philosophical beliefs about a major aesthetics issue (or issues). A newspaper article representing an aesthetics issue will be given to you. Read the article, identify the issue(s) in the article, and write about your beliefs concerning that issue. Please ground your response in the content of aesthetics, as we have studied it in class. Refer to major philosophers, theories, and beliefs in the field. Your essay should not be longer than two pages.

by their discussion and use of references to the field; processes in aesthetics, including analyzing arguments, comparing, making and judging value judgments, constructing support, reasoning, inventing, describing, defining, and presenting a position or argument; other cognitive processes, such as taking and reviewing notes, structuring and organizing information or extended written text, paraphrasing, analogizing, making connections, outlining and ranking, recognizing underlying principles and concepts, reflecting, and explaining to others. Writing skills, such as organization, spelling, punctuation, and grammar could also be assessment criteria. A good essay can potentially become a tool for assessing many skills simultaneously.

Scoring can be a major disadvantage with essay items. The following guidelines can help ease scoring problems:

• Prespecify if scoring is going to be *holistic* (one overall score for quality) or *analytic* (several different elements are scored for quality). For a task with many dimensions, analytic scoring is the best

choice; and for a task with no specific right answer, holistic scoring is recommended.

• Create model answers and a scoring guide (number of points for right answers) before finally deciding to use a particular question. For holistic scoring, place judged essays in piles of A, B, C, and D, frequently going back if necessary to reorder piles. When all essays have been read and placed, go back and examine each pile to make certain all seem to fit comfortably into their respective piles. For analytic scoring, list all content and structure dimensions and possible points for each.

• Score essays anonymously. In other words, be sure you do not know the name of the student whose essay you are scoring.

• Remain open-minded. Allow for a good answer that was not prespecified.

• If necessary, ask a second scorer to review the essays.

Although there are other ways to categorize tests, such as group and individual, speed and power, aptitude, achievement, and interest, the types discussed here are the most relevant to the visual arts educator. A test is but *one* way to assess student learning outcomes. Other traditional ways are described in the remainder of this chapter.

Questionnaires and Inventories

Questionnaires and inventories are sometimes called *self-reports* because they indicate what students can do or what particular interests or attitudes they hold. Both open-ended and closed questions are used on questionnaires. Other popular item types are fill-in the blanks; checklists, in which students mark all examples that apply; scaled items, which require that students rate provided examples; and ranking questions in which students indicate order of preference. Questionnaires work well as a tool for assessing art-making processes and techniques. To assess students' knowledge of a particular printmaking technique, for example, the art educator might construct a questionnaire in which students have to identify the correct steps for pulling a print.

Questionnaires can also function as adjunct strategies for clarifying other complex performance assessment tasks, such as portfolios, simulations, or extended integrated performances. As the student completes the performance task, an accompanying questionnaire can emphasize or enhance certain dimensions of the task. Questionnaire items can be constructed to show whether the student is able to:

- make appropriate comparisons among concepts by rating the concept from least to most appropriate.
- rank most likely causes.
- determine correct relationships between two events, principles, concepts, or facts.

- offer appropriate explanations for why something occurred by filling-in the blank with an appropriate explanation.
- make correct predictions by filling-in the blank predicting what will happen.
- determine correct examples of a principle or concept by checking all examples that apply.
- evaluate outcomes by rating degree of quality or intensity.

In addition, students can document their thinking processes using a questionnaire administered during or immediately following a performance assessment task. Students might select from a list of processes all those that relate to their performance. They can also rank order how meaningful such processes were to the performance. Moreover, a questionnaire item can solicit from students the degree of frequency that a particular thinking process was used in the performance task. Assessment Strategy 18 shows questionnaire items that might accompany a performance task in art production and yield evidence of problem-solving skill development.

Questions 3, 4, 5, and 6 enable the art educator to look at students' metacognitive practices. Question 6 also gives evidence of a problem-solving model (Letters a, b, e, f, j, l, m, n) as well as how smoothly students executed the performance (Letters c, d, g, h, i, k) and student attitudes (Letter o).[9]

The questionnaire or inventory has several other important uses as an assessment strategy, singularly or in conjunction with a performance task. Questionnaires can be used to assess student motivations, student attitudes toward art learning, student commitment to an art task, and student interests.

Assessment Strategy 19 on page 55 shows an example of a questionnaire designed to identify creative characteristics revealed in students' execution

Art-Making Process Questionnaire

As you worked on your art project, you were involved in many different problem-solving skills. These questions help you describe your personal visual problem-solving skills. No answers are considered right or wrong.

1 Describe three major ideas or concepts that you needed to know to be able to create your artwork.

2 In essence, it is the rule (or principle) behind the concept or idea that you needed to understand and apply successfully in order to create your artwork. Describe an art rule or principle that lies at the heart of each major idea listed in Question 1.

3 To find answers to your ideas or concepts, you needed to go through certain processes or procedures. Identify and rank the most important problem-solving processes that you practiced when creating your work. If you could share one key process with your classmates, which would it be?

4 Can this list be defined as_____ (your name)'s Personal Art Problem-Solving Process for using again and again? Circle the correct response.
Yes No

5 If no, then what is missing or lacking in your personal problem-solving process?

6 Sometimes, our problem-solving processes are smooth and automatic or they may require us to stop, rethink, and reorganize. Please circle the responses that best fit your artistic working process.
a. tried to see the whole art task and not just the details of it
 1 2 3 4 5

b. rushed into solving the problem, going with my first solution
 1 2 3 4 5

c. ran into problems
 1 2 3 4 5

d. had to stop and ponder about what I had done
 1 2 3 4 5

e. created sketches or models to help solve problems as they arose
 1 2 3 4 5

f. turned the problems into questions and changed the questions if I could not solve them
 1 2 3 4 5

g. had to redo parts
 1 2 3 4 5

h. changed ideas or directions
 1 2 3 4 5

i. had to stop and figure out what to do next
 1 2 3 4 5

j. tried working backwards, starting with a finished vision of the end product and worked toward that end or goal
 1 2 3 4 5

k. asked for help
 1 2 3 4 5

l. kept track of partial solutions in my journal, so that I could go back and revisit them if necessary
 1 2 3 4 5

m. asked myself where I have seen a problem similar to this one or solved a similar problem
 1 2 3 4 5

n. talked through the problem and kept asking myself about it until a solution was suggested
 1 2 3 4 5

o. felt frustrated and discouraged
 1 2 3 4 5

of a particular art assignment.[10] Creative people, according to Csikzentmihalyi, experience both extremes of a given category; for this reason, one polar position is not considered less creative than the other.[11] From the results of the questionnaire, the art educator would know how students reacted to the art task with respect to these creative poles. A comparison of responses and the actual artwork might yield interesting results. Repeated administrations of the questionnaire could indicate a creative pattern in some students and/or a creative pattern in a required art task. The student who never appears to experience the creative extremes and who marks consistently in the middle positions would merit further consideration and attention.

Assessment Hint

Questionnaires work particularly well as a tool for assessing students' knowledge of processes that might potentially be dangerous. Teachers can use the questionnaire before students actually engage in the craft process to assess whether they have sufficient knowledge to carry out the process safely.

Assessment Strategy 19

Creative Characteristics Questionnaire

Please place an X in one of the seven spaces to indicate the extent to which each phrase describes your "creative juices" during this art project. Remember, there are no right or wrong answers.

When creating this art project, I felt:

#			
1	physically energetic	— — — — — — —	quiet and at rest
2	naive	— — — — — — —	smart
3	disciplined and wanting to persevere	— — — — — — —	playful and not so serious
4	passionate	— — — — — — —	detached
5	introverted	— — — — — — —	extroverted
6	proud	— — — — — — —	humble
7	cooperative	— — — — — — —	competitive
8	imaginative	— — — — — — —	a sense of reality
9	traditional and conservative	— — — — — — —	rebellious
10	enjoyment	— — — — — — —	agony or pain
11	gender-specific oriented	— — — — — — —	non gender-specific oriented

Art of the Nineteenth Century

Directions:
Write the number of each slide shown in the corresponding box(es) within the grid.

Symbolism	Monet	Ingres	Impressionism	Turner
Goya	Romantism	David	Homer	Neoclassicism
Courbet	Pre-Raphaelites	Canova	Expressionism	Constable
van Gogh	Manet	Realism	Post-impressionism	Delacroix
Munch	Eakins	Gauguin	Rossetti	Renoir

One of the most popular types of scales used on a questionnaires designed to measure attitudes and values is the Likert scale, developed in 1932 by Rensis Likert. (For more on Likert scales see Chapter 4, Rating Scales, page 63.) Respondents indicate their attitude toward a topic by marking whether they "strongly agree," "agree," are "undecided," "disagree," or "strongly disagree." These verbal categories are weighted with numbers 5, 4, 3, 2, and 1, with 5 representing positively-stated items.

Assessment of affective-related objectives, such as attitudes, beliefs, values, or feelings about art should be used primarily for the purposes of formative evaluation and not for giving grades. The art educator with knowledge of students' affective characteristics is better able to make decisions and judgments about the program in progress.

Visual Identification

Requiring identification of an object is a method of assessing knowledge of art history familiar to most art educators. In the visual identification test format, students look at art images (usually slides) and identify the art image that best matches the concept being examined. Multiple-choice, matching, true-false, completion, and short and extended essay task formats are often coupled or linked with identifying the image. The strength of the visual identification strategy depends on what the art educator asks students to do with the selected images. Simply identifying the image as an example of Impressionism or of the work of a particular artist does not assess complex thinking skills. Such exercises, however, can be used successfully with very young children or for formative evaluation purposes.

To use the visual identification format to assess complex thinking skills, the art educator might try developing a matrix with cells representing examples and nonexamples (verbal or pictorial) of the concept to be assessed. As students view a series of numbered images, ask them to place the corresponding number in the correct cell. Used with a matrix, visual identification becomes a type of matching assessment strategy. This particular combination of test formats lends itself to assessing higher-level thinking when the art educator constructs a matrix with cells that go beyond simple factual information or recall. Including cells that contain underlying principles and issues or require students to supply their own information will enhance this assessment strategy. Assessment Strategy 20, on page 56, shows an example of a matrix created to simply identify a series of slides relating to nineteenth-century art.

How Useful Are Conventional Testing Formats?

Should conventional testing formats be a part of the art assessment program? Many believe that it is not test format, but rather test content and standards that most impact educational excellence. The art educator must determine for him or herself whether traditional testing formats best address his or her assessment objectives.

Pencil-and-paper varieties of tests are useful for ongoing formative evaluation and assessment of facts and knowledge, or in conjunction with performance tasks to help verify, define, or explain certain processes or procedures. Opportunities for meaningful, student-driven assessment that is closely tied to instruction abound in the art classroom. Why should the art educator not capitalize on these unique assessment opportunities offered by the art classroom and leave the less personalized, decontextualized testing formats for large-scale assessments?

Notes

1 D. Asay, *Celebration of Diversity*, (Orem, UT: Art Visuals, 1996).
2 A.J. Nitko, *Educational Assessment of Students*, 2d ed. (Englewood Cliffs, NJ: Charles E. Merrill Publishing Co., 1996).
3 See note 2 above.
4 E.S. Quellmalz, "Developing Reasoning Skills," in *Teaching Thinking Skills: Theory and Practice* eds. J.R. Baron and R.J. Sternberg (New York: Freeman, 1985).
5 G. Perry, *Paula Modersohn-Becker* (New York: Harper and Row, 1979).
6 Hetsch as cited in Perry. See note 5 above.
7 See note 5 above.
8 See note 5 above.
9 R.M. Cyert, "Problem Solving and Educational Policy," in *Problem Solving and Education: Issues in Teaching and Research*, eds. D.T. Tuma and F. Reif (Hillsdale, NJ: Lawrence Erlbaum Associates, Inc., 1980); and N. Frederiksen, "Implications of Cognitive Theory for Instruction in Problem Solving," *Review of Educational Research* 54.: no. 3 (Fall 1984): 363–407. The problem-solving portion of the questionnaire in Assessment Strategy 18 is based on these two works.
10 M. Csikszentmihalyi, *Creativity* (New York: HarperCollins Publishers, Inc., 1996).
11 See note 10 above.

Chapter

4

Scoring and Judging Strategies

Across the crowded hotel lobby, two old friends spy each other. They both teach art now, and are attending a state education conference emphasizing assessment. After greeting each other, they reminisce about their college experiences.

"Do you remember receiving marks of 6 or 7 on our artworks, and not knowing what those marks meant?" Sally Young asks.

"Yes," replies Anna Sirokman. "I never understood what was wrong with my paintings when I received a 4 or a 6. And what made the difference between an 8 or a 9? Do you remember those awful interrogations we had to sit through?"

"You mean *the critique*?" Sally responds with a grimace and a laugh. Her expression slowly sobers. "You know, Anna, I find myself marking students' work in much the same way. I don't seem to be doing anything very differently."

"And I still have the same kind of critiques," Anna admits. "Maybe they are as painful for some of my students as they were for us."

anchor Measure or unit on a rating scale.

benchmarks Examples of performance levels appropriate to designated anchors. Also referred to as standards.

continuous assessment strategies Ongoing assessment with both formative and summative applications.

objectivity The degree to which every scorer arrives at exactly the same results.

objective test A test is said to be objective if a set scoring key is used and all scorers arrive at the same score outcomes. Multiple-choice questions represent an objective-type test.

ordinal scale Each position or anchor is lower or higher than the one next to it. The magnitude of difference between the positions or anchors is not known.

probe A teacher-constructed question related to the task, assessment criteria, or student's own thinking about his or her cognitive processes.

subjectivity The degree to which a scorer arrives at a score that is different from that of another scorer or from his or her own score at another scoring period.

subjective test A test is said to be subjective when scorer's results are allowed to vary. Essay questions are examples of a subjective-type test, although essay formats with carefully structured scoring can become more objective.

Both Anna and Sally realize how their current assessment strategies mirror the models they experienced in their preservice art education programs. The issues they raised about scoring and judging strategies are germane. How can the art educator help students make sense out of a 4 or a 7 on a rating scale of 1 to 10? Are there better ways to conduct a critique of artworks?

What does the art teacher need to know in order to create quality scoring strategies that are not baffling to students? This chapter focuses on eliminating the mystery surrounding scoring and judging strategies. Two terms are significant to a beginning discussion on scoring and judging—*objective* and *subjective.*

The Objective/Subjective Distinction

Although the terms *objective* and *subjective* are sometimes used to describe test types, in fact they relate more to the way in which a test is scored than to its actual format.

Scoring or Judging Examples

A performance-based assessment task needs to be rated, judged, or scored. The choice of scoring strategy depends on the type of assessment information needed. In order to design a scoring plan, the art educator first needs to understand different scoring options. The following section provides examples from which an appropriate match can be made between performance assessment strategy and scoring strategy.

Checklists

Checklists specify behaviors, characteristics, processes, or activities and a place for recording whether each is present or absent. Because they work so well with performance strategies, checklists have become

a popular assessment strategy used in both formative and summative roles. They also combine well with other scoring methods, such as rating scales and observations. Checklists are particularly useful for indicating knowledge pertaining to the correct steps in a particular art procedure, student interests and motivations, work that is or is not completed, characteristics present in an art product, and student learning processes.

The sample checklist in Assessment Strategy 21 is designed to correspond with an assessment of students' abilities to write a critical review. Specifically, the checklist assesses students' ability to identify and relate their critical thinking processes to their written art criticism. (Checklist items are derived from Chart 1, page 132.)

In addition to identifying what thinking processes they have used, the sample checklist also asks students to reflect on the point during the writing of the critical review these processes were applied. If a section or stage of the critical review is found to be problematic, then the student can go back and examine the thinking process involved in that particular section. Hence, the reflective task also assesses students' metacognitive skills.

Tallies

Tallies track the number of times a certain behavior or event occurs. In the art program, tallies might determine how many times students, in the process of writing an art criticism paper or art-historical report, use certain processes, such as analyzing, comparing, or interpreting. The purpose for such a tally would be to help students understand their own thinking and problem-solving processes. Tally records can also keep track of how many times a student asks for help. The most common reason for keeping a tally sheet is to correct a specific behavior.

Assessment Hint

When devising a tally sheet be sure to allow space for commentary about the behavior.

Scoring and Judging Tools
- Checklists
- Tallies
- Rating Scales
- Critiques
- Teacher Interviews
- Peer, Parent, and Other Interviews
- Student Self-Assessments
- Observations

Checklist of Art Criticism Processes

After you have finished writing a critical review of your selected artwork, using a model of criticism, please think about the different critical-thinking processes (listed below) you exercised during the creation of your review. This list is derived from what professionals say they do in their role as art critic. Place a check in the space before the appropriate process.

Please attach this reflection task to your critical review.

Did you:
- [] 1 observe
- [] 2 describe
- [] 3 explain
- [] 4 characterize (to describe or distinguish the quality of something)
- [] 5 analyze
- [] 6 seek evidence and counterevidence
- [] 7 construct support
- [] 8 interpret
- [] 9 compare and contrast
- [] 10 invent
- [] 11 give reasons
- [] 12 make value judgments and judge them
- [] 13 evaluate
- [] 14 analyze errors
- [] 15 reorder and revise
- [] 16 present a position or argument

If you need to explain briefly how you were involved in a particular process, not easily documented in your written report, then please do so in the following space:

Then, indicate on your critical review paper where you felt you were actually involved in that particular process. Write the number assigned to the critical-thinking process in the margin beside the text that best represents the process. Here is a student example of characterizing from a critical review:

The sculpture, as a whole, reminded me of the wing of a bird, mainly because of the

4 glass feathers on the top portion. The shiny steel rods crisscrossing the piece appear as the bird's muscles, bones, and tendons; the coordination that is needed to fly.

—A student's formal characterization of the sculpture *Seer* by Brower Hatcher.

Assessment Hint

To adapt Assessment Strategy 21 for young children, the elementary art specialist can conclude an art criticism discussion with the following oral questions: "When did we observe today? Describe? Explain? When did we analyze? When did we interpret? Compare and contrast? When did we invent? When did we give reasons for our beliefs?"

Assessment Hint

If you use simple or student-lingo anchors, then make sure that you and your students together discuss anchors and agree on what each actually means with respect to artwork.

Rating Scales

Rating scales rely on a numerical, verbal (sometimes called *category*), or graphic system for translating judgments of quality or degree. They are particularly appropriate for examining problem-solving processes, products, and attitudes or motivations. Various assessment strategies employ a rating scale as part of their design.

Measures or units on a rating scale are known as anchors. Whether anchors are verbal (words or descriptive phrases), graphic (line segments), or numerical (1, 2, 3, 4, 5), they must be clearly defined. Well-defined anchors increase objectivity in scoring. Student understanding is assured when students help define anchors. Likert-type rating scales use anchors such as, "Always," "Very Often," "Often," "Sometimes," "Hardly," "Hardly Ever," and "Never." For classroom art assessment, simply-stated anchors, such as "Can't Do," "Can Barely Do," "Can Do," "Can Do Well," and "Wow!" or student-lingo anchors, such as "Sad," "Not So Hot," "OK," "Cool," and "RAD!" (Really Artistically Developed) are effective.

4.1 Hatcher, Brower, Seer, 1995. Mixed media, 22' (6.7 m). Museum of Art, Brigham Young University, Provo, UT.

Assessment Hint

Use the computer as a library or depository in which you store and easily access benchmarks.

Assessment Hint

Consider beforehand how members of your class will respond to blunt verbal anchors, such as "Sad" and "Not So Hot." While colloquial and to the point, such labeling could present problems for some students. If this is the case with your class, then use numbers, such as 1, 2, 3, 4, and 5, instead.

Assessment Strategy 22

Tables Rating Scale

Place five tables in a row to emulate a large visual rating scale, with each table representing an anchor on the scale. Assign each table an anchor level such as, "Sad," "Not So Hot," "OK," "Cool," "RAD!" Ask students to help develop the descriptors for each anchor. If desired, assign a score to each anchor. Place products that represent benchmarks for each anchor on the appropriate tables. Suggest that students compare their own products with those displayed on each table. Then, ask them to place their own work on the table where it best fits according to anchor descriptions and benchmarks.

This strategy can assess a concept or technical process, such as coiling skills in ceramics, as well as a finished product. Allowing students to rework and improve their product after this initial rating strengthens students' abilities to monitor their own learning.

[Cognitive skills: comparing and contrasting, classifying, analyzing, judging/evaluating]

Rating scales are *ordinal* scales, which means each position or anchor is lower or higher than the one next to it (that is, positions are ordered and each has meaning). What is not determined, however, in an ordinal scale is the magnitude of differences between the numbers or anchors (i.e., the size of the intervals between the positions is unknown). Whether to use four or five anchors on a scale is really a matter of personal preference. Some prefer an even-anchor scale because it does not allow for a center or neutral position. Others maintain that an odd-anchor scale defines the ends more precisely.

A rating scale with well-defined levels of achievement for each anchor is the basis of a *scoring rubric* or *matrix.* (see Chapter 2 for examples of scoring rubrics and Chapter 6 for guidance in creating one.) *Benchmarks,* or descriptors of performance levels with designated anchor units, should be made available to the students for preview. For instance, if an art product is to be evaluated using a rating scale, then students should be given beforehand an example of a "Sad" artwork, a "Not So Hot" artwork, and an "OK" artwork, and so forth; each example is accompanied by a written explanatory description. This allows students to make comparisons with their own work before evaluation occurs. The self-assessment strategy shown in Assessment Strategy 22 (left) is based on the idea of displayed benchmarks.

Examples of rating scales are shown in Assessment Strategy 23 and Assessment Strategy 24. (See pages 65 and 66.) The first scale, Assessment Strategy 23, is a generic model for assessing an art product. By adding specific descriptive information about each performance level, the art educator can use this scale to form the basis of a scoring rubric for a specific art product. Both rating scales emphasize cognitive processes of reflecting and judging/evaluating.

Rating Scale for an Art Product

Directions: Listed below are assessment criteria related to performance in art production (studio activities). Rate the quality of the performance by circling the number of the category which best describes your judgment on each item.

Key:
Numbers 1 through 5 correspond to levels of achievement, to be used in comparison with other performances you have known.
1 = below most others
2 = only fair compared to others
3 = competent and compares well
4 = well above the average
5 = one of the most outstanding

1 Overall or global intuitive impression of the artwork
1 2 3 4 5

2 Importance of the concept or idea undergirding the artwork
1 2 3 4 5

3 Goodness of fit between the artwork and its intent, purpose, or function
1 2 3 4 5

4 Quality of the relationship between task objectives or criteria and artwork
1 2 3 4 5

5 Personal point of view or signature
1 2 3 4 5

6 Evidence of contextual knowledge and research (personal, social, cultural, historical, philosophical)
1 2 3 4 5

7 Creativity (originality of idea or process, risk-taking, unusual and diverse solution to the problem)
1 2 3 4 5

8 Skill in handling expressive content
1 2 3 4 5

9 Skill in handling composition and form (elements and principles)
1 2 3 4 5

10 Exploration of characteristics and potential of chosen media
1 2 3 4 5

11 Craftsmanship (tools, materials, and techniques)
1 2 3 4 5

12 Honesty and integrity of artwork (acknowledgement of a standard for the material or the discipline and a personal honesty in conception, form, and structure)
1 2 3 4 5

13 Improvement and growth
1 2 3 4 5

Assessment Strategy 24

Circle Graph Rating Scale

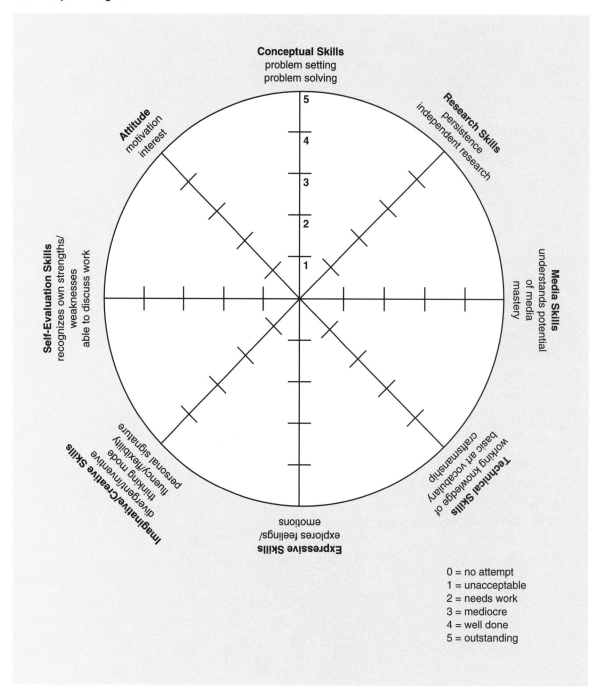

Conceptual Skills
problem setting
problem solving

Research Skills
persistence
independent research

Media Skills
understands potential
of media
mastery

Technical Skills
working knowledge of
basic art vocabulary
craftsmanship

Expressive Skills
explores feelings/
emotions

Imaginative/Creative Skills
divergent/inventive
thinking mode
fluency/flexibility
personal signature

Self-Evaluation Skills
recognizes own strengths/
weaknesses
able to discuss work

Attitude
motivation
interest

0 = no attempt
1 = unacceptable
2 = needs work
3 = mediocre
4 = well done
5 = outstanding

The second rating scale, Assessment Strategy 24 (left), is based on a circle graph. Teachers could create a smaller version with fewer criteria, developed around four radii (i.e., a cross). Criteria, in this rating scale, include a radius relating to attitudes. Students enjoy rating their own work on a circle graph, and the teacher can also rate their work using a different color for dots and connecting lines. An extension of the circle graph would be to have the class rate an artist's work, referenced to the product assignment, and compare their own efforts against those standards. In this case, the artist's example could be placed on an overhead transparency for easy comparison to students' own graphs.

Psychometricians have identified a variety of errors associated with rating scales. Among them are a tendency to:

- rate in the center and avoid either extreme (*central tendency error*).
- rate students' work the same in all categories based on a first or generalized high or low impression of the student (*halo* or *sudden death error*).
- give the subject the benefit of the doubt if not sure how to rate or a tendency to rate all individuals too low on all characteristics (*leniency* or *severity error*).
- judge an underlying principle (a construct such as creativity or writing ability) rather than the characteristic or behavior actually being assessed (*construct-relevant error*).
- judge too quickly (*jumping-the-gun error*)
- judge a student against the previous student (*comparison error*).

Understanding these possible pitfalls, the art educator can make a concerted effort to reduce the negative effects when using a rating scale.

Assessment Hint

When designed for the purpose of assessing students' abilities to make, interpret, and judge statements about art, the critique has potential as a performance assessment task as well.

Critiques

Although the critique is a discussion strategy, it differs significantly from the performance strategy, group discussion, described in Chapter 2 (see page 34). The group discussion *is* the performance assessment strategy, whereas the critique is a strategy that takes place during or after completion of the art performance task and is focused on assessing that art performance task. Critiques give insight into how the class as a whole understands and accomplishes a performance task. Widely used with art production activities, critiques have traditionally been a way of letting students know what improvements might be made in their work. Analogous to a large group interview, the critique generally lacks a clear-cut structure or learning objectives and, for this reason, is often viewed by participants as negative criticism. When used as a summative assessment tool, the groups' responses can serve as the basis for critique scores. Although the critique used for this purpose may occasionally have value, other more meaningful uses of the critique exist.

The critique is useful as an *informal* diagnostic assessment strategy in that it can pinpoint students' strengths and weaknesses in a nonthreatening manner. The key word here is "informal," that is, the critique is used for formative assessment. Summative judgments are most often translated into grades, whereas formative, or informal, judgments generally

are not. Using the critique as an informal diagnostic assessment strategy, the teacher might ask small groups of students to conduct their own critiques focusing on what has been learned, what needs to be learned before objectives are met, what connections can be made to other artworks, or how to talk about artworks appreciatively. Because this critique format does not pit one student's work against another's, the works to be discussed need not be completed or even represent the same project. The teacher provides direction for the critique and ensures that students address intended purposes and objectives.

Critiques can also function as *continuous assessment* strategies, that is, on-going assessments with both formative and summative components. To modify an informal critique format for use as a summative assessment, the art educator would need to:

- select performance task criteria to be discussed in the critique.
- define achievement levels for each task criterion.
- assign scores for each achievement level.
- design a way for students to record their scores during the critique.

The four sample strategies that follow are based on work by Hartung.[1]

Teacher Interviews

An interview with the student gives the art educator insight into the understandings, feelings, attitudes, interests, and motivations of the individual and is, therefore, an excellent strategy for gathering diagnostic information. In addition, such interviews provide information about students' thinking processes. For example, asking a student to demonstrate how he or she groups, orders, and categorizes artworks, or, how he or she takes and reviews art history notes can reveal a student's particular learning problems

Assessment Strategy 25

Thumbs Up, Thumbs Down

The assessment criteria of a task are the subject of class discussion. Students indicate the presence or quality of a criterion by a thumbs-up or thumbs-down gesture. This particular method works well as an introduction to critique strategies. The art educator should structure the thumbs-up, thumbs-down critique around something students have already learned. An example of a thumbs-up, thumbs-down strategy is: "If you see three examples of mixed colors in the painting, then give it thumbs up. If not, then give the painting thumbs down."

Assessment Strategy 26

Word/Phrase Cards

In this critique format, words or phrases, based on task criteria, are written on cards. Art products (not necessarily limited to studio products) are exhibited on tables, and students choose the work that best exemplifies a particular word or phrase and place beside it the appropriate card. Concepts, formal elements, media, research, expressions and moods are all possible categories from which words or phrases might be selected. When all cards have been placed beside an art product, students then discuss and give reasons for their choices. The art projects, with all awarded word cards, are turned in to the teacher for final assessment. Diversity and quantity of awarded cards could be assessment criteria that are translated into a score for a summative evaluation.

Assessment Strategy 27

Effective Analyses and Interpretations

Art reproductions related to the art assignment or professional examples of written work, such as art criticism or an art historian's or artist's commentary, are used as category markers. Students place their own work in the appropriate category, analyze the similarities and differences between their work and the markers, and give reasons for the conclusions they have reached. Two applications are as follows:

1 The teacher displays three samples of descriptions written by three different art critics; for example, a formalist or philosophical-based description, a description using flowery prose and similes, and a description comprised of a few concise statements. Students match their own writing with one of the examples, then give reasons explaining why they placed their own writing alongside a particular example.

2 Art reproductions that exemplify different philosophical stances such as *formalist* (based on elements and principles), *imitationalist* (based on realism), *expressionist* (based on expression of feelings and emotions of the artist), *feminist* (based on understanding of female-related issues and dispositions), and *instrumentalist* (based on purposes or causes) are placed on tables. Students align their own artworks with the most appropriate category and give reasons for their placements.

The second example enables a wide variety of student work to be discussed at the same time. In both applications, students are judged on their abilities to analyze, interpret, and judge their own works and to give supporting reasons for their positions.

Student Portfolio Interview Schedule

1 Describe the overall quality of your portfolio to me in terms of **unacceptable, needs work, mediocre, well done, outstanding**. Defend your position.
Negotiated position: _____
Moderator's comments: _____

For each of the following questions, allow for "Negotiated position" and "Moderator's comments" and use the boldfaced terms in Question 1 with each instruction to "describe." At the end of each evidence question, add "Explain."

2 Is your portfolio complete? Explain.To what degree does your portfolio exhibit a sufficient quantity of work? (Describe.) Where is evidence of preparatory work and final work pieces?

3 To what degree does your portfolio exhibit creative or personalized thinking and processing? (Describe.) Where is evidence of original ideas?

4 To what degree does your portfolio reflect your life, your environment, and your culture? (Describe.) Where is evidence of contextual influences in your work (personal, social, cultural, historical)?

5 To what degree does your portfolio exhibit knowledge of art history, art criticism, and aesthetics? (Describe.) Where is evidence of learning in each of these disciplines?

6 To what degree does your portfolio exhibit visual problem-solving abilities? (Describe.) Where is evidence that you have set up a problem, conducted research, explored various visual solutions, made revisions, and arrived at a final conclusion?

7 To what degree does your portfolio exhibit application of basic art vocabulary (i.e., elements and principles)? Composition? (Describe.) Where is evidence that you have applied knowledge of design elements and principles?

8 To what degree does your portfolio exhibit technical proficiency in processes of art-making and art-reflecting? (Describe.) Where is evidence of craftsmanship or skill in handling tools and materials used? In writing about art? In questioning ideas about art?

9 To what degree does your portfolio exhibit evidence of your individual initiative and your interests? (Describe.) Where is evidence of your enthusiasm for making and learning about art?

10 To what degree does your portfolio exhibit concern for presentation? (Describe.) Where is evidence of care taken in preparing, submitting, and documenting your work?

To this incomplete list of interview questions, the art educator might add others requiring students to produce evidence of the following topics:

- collaborative efforts between student and teacher and/or other students.

- what was learned from your least successful or unresolved piece? How could it be reworked or solved?

- what makes your most successful work different from your least successful?

- describe a piece that shows revisiting and reworking an idea or use of feedback information.

- strengths and weaknesses in art.

- self-discovery such as individual style, attitudes toward art, and preferences in art through portfolio creation.

- discarded misconception(s) about art as a result of portfolio creation.

- art rules or principles learned during portfolio creation.

- where to go from here in art study.

and/or other obstacles impeding progress. Interviews are useful tools for assessing students' knowledge and skills in all four visual arts disciplines.

Assessment Strategy 28 (page 70) shows an interview schedule designed not only to assess a portfolio but also to yield evidence about students' cognitive processes. For older students, the schedule combines questions with a rating scale for self-assessment. The plan also features a negotiating component, in which the teacher and student discuss their respective positions and together arrive at a final rating. For use with younger students, this plan can be modified by simplifying some questions and deleting the rating scale component and more difficult questions.

Peer, Parent, and Other Interviews
This category is similar to teacher interviews but uses interviewers other than the classroom teacher, such as students, parents, guardians or family groups, other teachers, school administrators, and art-related professionals. By involving parents, guardians, or family groups in the evaluation process, student assessment becomes a shared venture. Ideas for how the art educator might set up interviews between students and others sources follow.

- The art teacher, in conjunction with students, prepares an interview plan, which is sent home with the art portfolio to be reviewed. Student and parents or guardians complete the form together and return it to the teacher.
- Several video tapes that show students working on, discussing, and exhibiting their finished art products are made at various points in the art course or school year. One student takes a video tape home for family viewing and discussion. The video tape is accompanied by an interview schedule to be filled out and returned along with the video tape, which is then sent home with another student in a round-robin fashion.

Assessment Hint:

To ensure a successful interview, try these suggestions:

- Think about what you want to learn from the interview; prepare in advance a list of questions to ask.
- Find a quiet place to hold the interview; be sure that other students are quiet and occupied.
- Begin the interview with broad questions and then move to more specific, focused questions.
- Allow for questions to emerge from your conversation with the student. Remember: one of the great advantages of an interview is its flexibility.
- Take notes. It is important that you accurately record the student's responses.
- Keep the interview brief.
- Avoid intimidating the student with too many quick questions.
- Create an atmosphere that puts the student at ease.

Assessment Hint

Consider adding to the Student Portfolio Interview Schedule a final item for remarks concerning the student's abilities to discuss and reflect upon the portfolio. Students would demonstrate these abilities by the extent to which they answer questions meaningfully and thoughtfully.

Assessment Hint:

Self-assessment strategies can include other scoring and judging strategies such as checklists and rating scales.

Assessment Strategy 29

Mini-Portfolio Parent Interview

Directions: Take home your completed and organized mini-portfolio. Have a parent or guardian look through all of your projects. Then, interview that person by asking these questions:

1 What did you learn about _____(focus of mini-portfolio) from looking through this portfolio?

2 Which piece in the portfolio is your favorite and why?

3 Which piece in the portfolio is your least favorite and why?

4 How do you feel about my artistic skills as demonstrated in this portfolio? My analytical skills? My creative skills?

5 If you could give me one piece of advice for work on future art projects, then what would it be?

- The art portfolio is scanned on the computer. The student takes his or her individual portfolio disk home for viewing and discussion. In addition to the student art portfolio, the disk also contains an interview schedule to be completed and returned with the disk. Students periodically update their disks.
- The art educator invites guests to conduct brief interviews with students. Beforehand, guests are given a prepared interview schedule.
- School administrators set aside a short amount of time for interviewing students.
- The art educator sets aside classroom time in order for students interview each other about their work.

Assessment Strategy 29 presents an interview schedule designed to go home for family involvement in assessment. Based on one created for junior high-school students, the schedule is crafted to accompany a mini-portfolio.

Student Self-Assessments

Self-assessment is a key feature of the performance assessment movement, and a skill that traditionally all educators try to teach their students. The art educator needs to involve students in the drafting of

Types of Student Self-Assessments
- Journal Probes
- Annotated Portfolios
- Learner Reports
- What's the Principle? What's the Problem?
- Dual Juror Viewpoints
- Measuring Sticks
- Constructed Response Items

Journal Probes

Choose four of the following probe questions to answer in your journal:

1 As you looked at numerous triptychs in an art museum or in a book, what thing/object/idea did you observe keenly in a triptych? Why? [Cognitive process: observing and describing]

2 What puzzled you most when looking at a particular triptych? [Cognitive process: puzzling and questioning]

3 How might you group or categorize the different triptychs you have seen? [Cognitive processes: grouping/ordering/categorizing information]

4 Describe or sketch in your journal the mental image you have of your own proposed art triptych. How are you able to envision your own art triptych before you begin working on it? What causes you to alter or change that mental image? [Cognitive Process: elaborating information by using mental/symbolic images]

5 What are three underlying art principles or rules you have discovered which appear to be central to making a triptych? [Cognitive process: recognizing underlying principles/rules/concepts/structures]

6 Have you thought about your proposed triptych as a mathematician might think? An author or a poet? A person concerned with others? A lover of nature or science? Other ways? Explain one or more ways. [Cognitive processes for thinking in multiple-intelligent ways]

7 What personal goals do you wish to accomplish in your triptych? [Cognitive process: recognizing which goals to set, establishing goals, and determining if they are met]

8 What assessment criteria should be used for evaluating your triptych? [Cognitive processes: judging/evaluating]

9 What misconception(s) did you have about triptychs and what caused you to change your mind? [Cognitive process: recognizing preconceptions and misconceptions]

Assessment Strategy 31

Annotated Artworks

> *Leave a three-inch margin around your artwork or place a larger sheet of paper under your image to create a margin. In that margin, address the three items listed below. Indicate, by using a Post-it® note or a color-coded label dot, the part of your work that relates to your margin notes.*
>
> 1 Select three "I like this part" areas in your work. Explain reasons in the margin.
> 2 Select one "I don't like this part" area in your work. Explain reasons in the margin. Suggest a possible solution.
> 3 Write a "Help me!" question requesting help or advice related to an area that is problematic for you.
>
> When you have finished, give your artwork to a peer, the teacher, or family member to make critical comments in the margin pertaining to your comments.

Assessment Hint

Suggest that students save this self-assessment sheet and use it later to revisit and rethink, revise, or rewrite their original annotations. Used in this manner, the form becomes a well-documented example of changes in students' thinking and work process.

self-assessment strategies, with the possible exception of those that address metacognition or complex cognitive processes.

Student involvement in the crafting of strategies that they will use to assess themselves helps to address validity, the issue of straightforwardness or transparency of all parts of the assessment. Every aspect—format, directives, expectations, standards, and scoring criteria and methods—is visible. Students are more apt to view assessment as a valuable ongoing learning experience if they are an integral part of the whole process.

Journal Probes

The student journal, described earlier as a performance strategy, can also function successfully as a self-assessment strategy. The art educator might try combining the journal with *probes*, that is, teacher-constructed questions related to the task, assessment criteria, or the student's own thinking about his or her cognitive processes.[2] For example, if the task requires students to create a triptych of themselves slaying their own symbolic dragons, based on a study of triptychs and the theme of *St. George Slaying the Dragon*, the art educator might design several thoughtful probes, such as those shown in Assessment Strategy 30 (page 73). Bracketed information in Assessment Strategy 30 indicates cognitive processes and core skills central to each probe.

Annotated Portfolios

Generally speaking, the annotated portfolio is a strategy that requires students to explain their portfolios in terms of goals and objectives and therefore, assesses the cognitive processes of reflecting and explaining to others. Annotated portfolio techniques are central to the expanded portfolio because they encourage students to "show and tell"

Learner Report

	Universal	**Existential**
World Knowledge (about art)	Rules of, about, or in art *Stem =* I have discovered that . . . I have learned how to . . .	Surprises, unexpected learnings, exceptions to preconceptions about art *Stem =* I have discovered that I changed my mind about . . .
	A	**B**
Self-Knowledge (about art)	Rules about myself, personal habits in art *Stem =* I have discovered that I am . . . I have learned that I always . . .	Surprises about myself, exceptions to preconceptions regarding myself, unexpected possibilities, new ways open to me about art *Stem =* I was surprised to learn that now I like (or dislike) to . . .
	C	**D**

what they know and think about particular works included in the portfolio. Assessment Strategy 31 (page 74) demonstrates an easy format for implementing the annotated portfolio.

Learner Reports

In *learner reports*, students are asked to use open-ended responses to assess their own learning. Based on a model used in The Netherlands, the learner report presented in Assessment Strategy 32 above addresses four kinds of learning: (a) world knowledge, including rules, facts, theories, generalizations, and processes; (b) unexpected learnings, such as exceptions to preconceptions about world knowledge; (c) self-knowledge, including rules, facts, theories, generalizations, processes, and attitudes about one's self; and (d) unexpected learnings about self-knowledge.[3] Learning outcomes in both cognitive and affective domains are assessed in this model. Students are encouraged to give as many answers as possible to each stem. Responses can be discussed orally in a group session and tape recorded or written in student journals. Stems can be turned into questions for use on a questionnaire. The learner report can be crafted to use with one art discipline, a unit of study, or the entire course.

Other Self-Assessment Strategies

Assessment Strategies 33 and 34 use standards or benchmarks from art history, or aesthetics, or criticism. Benchmark examples relate to the students' art task. Prior to carrying out each strategy, students need to know which dimensions of their art task will be discussed and evaluated, what assessment criteria will be used, and by what criteria the self-assessment task itself will be assessed. Student responses can be written in their journals or in separate reports. The cognitive processes of synthesizing, judging/evaluating, reflecting, justifying, explaining to others, and expounding a viewpoint are possible skills to examine and record.

Constructed Response Items

Students can assess their own work by using a series of questions, called (in assessment terminology) *short-answer constructed-response items.* Teacher and students should work together to develop the questions students will later ask themselves. Questions need to address task objectives and assessment criteria, and can relate to tasks in art history, art criticism, aesthetics, and art production. A list of questions suitable for students at the elementary level concerning their studio artwork is shown in Assessment Strategy 36 (page 78).

Observations

Observation can be informal or structured. Observing students while they work not only reveals student behaviors and habits but also how well instruction is working. Most of the information used for formative evaluation is gathered by observation.

If a skill or technique in art production is being evaluated, then observations can be done at stations. This kind of observation is both systematic and structured. The assessment of skills such as techniques in

Assessment Strategy 33
Dual Juror Viewpoints

Two different viewpoints held by two "jurors," whom the teacher and, possibly, students select to judge student works, forms the core of this strategy. Jurors' beliefs, writings, or artworks are presented to the students. Students are then asked to write the evaluative statements they think their own artworks might elicit from each juror.

Two artists, each of whom has created significant drawings, are selected as jurors for a drawing task. One juror, for example, is an artist who draws in the tight, realistic manner of Chuck Close or Charles Sheeler. The second juror draws in the very loose, expressive style of Käthe Kollwitz or Oskar Kokoschka.

Students create the evaluative statement, based on specific assessment criteria, they imagine each artist might write when reviewing the students' own drawings. A precise photorealist, for example, might write favorable comments about a drawing that shows similar precise photorealistic techniques, while a more expressive artist might offer less favorable comments about such a drawing.

This strategy provides an opportunity for students to place their own work in a specific art-historical context, tradition, or stylistic mode or technique. Students' abilities to discuss the characteristics of two distinct stylistic approaches to art-making can be designated as assessment criteria. This strategy also works well for self-assessment of topics in art history, art criticism, and aesthetics.

Measuring Sticks

*In this type of self-assessment, students are
required to demonstrate knowledge of their
own art style, to assess their attempts at using
that style, and to reflect upon the relationship
between the selected measure and their own
work. Measurement units or benchmarks used
are taken from the real world of art. In essence,
this strategy can be likened to a large visual rat-
ing scale with exemplars as anchors. Although
Measuring Sticks can be easily designed to assess
art production outcomes, it also is useful for art
criticism and aesthetics. With practice, the art
educator can craft a self-assessment tool that
uses as measurement units written examples of
art criticism or philosophy. As students complete
this self-assessment strategy, they learn there is
no single, "correct" way to solve a visual arts
problem. Many different approaches can have
equally successful results.*

The teacher selects five examples or reproduc-
tions of artworks that relate to the art task
being assessed, but that represent vastly differ-
ent conceptions or styles. Examples that depict
the same theme, problem, or medium in styles
ranging from realism to conceptual would work
particularly well for this strategy. The teacher
places the artworks on a table in a continuum,
with both extremes at either end. Students
place their own artworks under the example
that most resembles their style and give written
reasons for their choice. Thus, this task asks stu-
dents to assess their own artworks in relation-
ship to a selected measure and then write about
that relationship.

What's the Principle? What's the Problem?

*This strategy assesses students´ abilities to
identify and apply fundamental rules and prin-
ciples, a skill that separates the novice from
the expert. This is a self-assessment strategy
that art educators can use to learn how well
their students can apply rule governed think-
ing to an art production task.*

Please identify three important principles or
fundamental rules about art that you believe
guided the successful creation of your artwork.
For example, a principle related to making a
triptych is: "Unity is achieved by organizing
the elements into a cohesive whole." Place a
different colored dot beside each principle to
code it.

1._____
2._____
3._____

When you have finished writing the principles
or rules central to your art task, please deter-
mine which principle might be the basis of a
problem in your artwork. Which principles
have you resolved satisfactorily? If you see
problems in your artwork that do not corre-
spond to one of your principles, then you may
go back and change a principle or add another
one. Place a corresponding colored dot (a peel
dot or a dot made on a Post-It® note) directly
on the areas represented by your principles.
Write your evaluative comments (positive or
negative) about that area and ways you might
solve the problem.

Assessment Hint

Try coupling some of these questions with a rating scale with simple anchors. This will give students the opportunity to assign a score to their artwork as well.

Assessment Strategy 36

Student Questions for Evaluating His/Her Own Work

1 Is the idea I wanted to show easy to see or understand? Explain.

2 Did I need more information or research about the idea/subject/figures and what it/they mean(s) or is/are doing? Explain.

3 Can I think of another way to show similar subject matter? Explain.

4 Did I show enough details to express what I had in mind? Explain.

5 Did I use my art materials in a new or different way? Explain.

6 Did I use colors (or lines) to give my artwork the right feeling? Explain.

7 Would using more light and dark values make my subject more important or interesting? Explain.

8 Did I discover new ways to make textures, use colors, lines, or shapes? Explain.

9 Did I fill the space satisfactorily? Explain.

10 Could I make some part more interesting? How would I do it? Explain.

11 Am I satisfied with this artwork? Explain.

12 Did I enjoy making my artwork? Explain.

painting, processes in ceramics, or steps in printmaking might be conducted at various stations set up around the classroom. Students visit the stations in a round-robin fashion and perform the required task. The teacher and several helpers observe and mark the presence or absence of certain behaviors on a checklist or tally sheets. They might also record the quality and degree of the presence of these behaviors with a rating scale or notes in a teacher's log. Please note, however, that checklists, tally sheets, and rating scales used to record behaviors are somewhat limited in that they note only the selected behaviors, designated and determined beforehand.

When recording observation data in an anecdotal record, select only a few students to observe at a time, for example, five students per class period, and use only a portion of the class period for the purpose of observation. Occasionally, the art educator may plan an observation period when only the most significant behaviors occurring among the whole class are noted. Teachers, particularly those with large numbers of students, may find it daunting, if not impossible, to keep an anecdotal record on each. Limiting the number of students and the amount of time allotted for observations is one way of making the task manageable. For special class activities that

Variables to Assess Using Observation Techniques
- Student Attitudes, such as anxiety, pride, self confidence, passion for art
- Student Perceptions, such as describes differences, analyzes visual effects in artworks
- Student Work Habits, such as uses time wisely, takes notes, stays focused
- Student Thinking Processes, such as orders and categorizes information, analyzes errors

Teacher's Log

To profile student attitudes and work habits, the following sample characteristics can be logged by placing the corresponding letters from both lists, with additional comments and interpretation, in the appropriate spaces below:

For student's level, characteristic rated is:

0 = Unacceptable (less than what is expected)

3 = Acceptable (average for what is expected)

5 = Outstanding (much more than expected)

Student Attitudes

A Shows interest in art class and in the visual arts

B Is receptive and cooperates with others

C Is self-motivated and self-starting

D Respects others' work

E Shows self-confidence

F Others

Student Work Habits

a Is willing to explore and experiment

b Uses art vocabulary

c Participates in class activities and discussions

d Uses original solutions in expressing ideas and experiences in artwork

e Completes assignments, shows, persistence, and works through difficulties

f Uses learned skills and concepts in new assignments

g Pushes boundaries of own knowledge and ability

h Others

Student: Mary

DATE	EVALUATION/COMMENTS	INTERPRETATION
	A-4	
	f-3	

The above notation would be interpreted as meaning: Mary shows high interest in art class and in the visual arts. Her use of learned skills and concepts in new assignments is acceptable and average for what is expected at this time.

Assessment Hint

For information related to other observable learning behaviors, such as complex thinking, information processing, effective communication, cooperation/collaboration, and effective habits of mind, read *Assessing Student Outcomes* by R.J. Marzano, D. Pickering, and J. McTighe (1993).

Assessment Hint

Try setting up rotation stations that enable observations to be made in the reflective disciplines. For example, stages of an art criticism model or steps in art-historical research might be observed at different stations. Observation stations work particularly well if the teacher needs to observe and score large groups of students.

Assessment Hint

One easy way to record a task requiring formal observation is to have a helper video tape the activity. Using a helper to video tape not only frees the teacher to act as a participant observer or capture the subtle nuances of the whole phenomenon in written descriptions, but also provides the teacher with permanent and detailed documentation.

require formal observation such as group performances and group discussions, the art educator needs to plan in advance how he or she will observe the activity.

To make anecdotal recording less cumbersome, the art educator will need to devise an easy format for jotting down notes. A small spiral-bound pad of 3 x 5" note cards works well for this purpose; with each student assigned a single card and cards organized alphabetically by class. Ideally, the teacher should note "who does what, when, where, why, and how" (WWWWWH). If necessary, this can be simplified to four notations (WWWW): (1) the student's name (who), (2) the date (when), (3) the incident or behavior (what), and (4) an interpretation about the meaning of the incident or behavior (why or what it means). One caution: avoid generalizations about a student's overall behavior. To be useful, notes should refer specifically to a single incident.

Assessment Strategy 37 (page 79) shows a sample teacher's log for observing and scoring students' attitudes and work habits that can be adapted easily to the note card format described above. Working from a master list of behaviors, each with assigned letters, the teacher notes the appropriate letters on each student's note card along with other comments and interpretative notes. To rate the behaviors, the teacher simply marks the number of the anchor that best fits the quality (or extent) of the recorded attitude or work habit.

Chapter 4

Quality scoring and judging strategies are essential for guiding sound judgments and maintaining consistent application for all students. Throughout this chapter, the art educator has been exposed to many different kinds of scoring and judging strategies—strategies that can be used effectively with performance-based assessments. From this selection or from new ideas they might have generated, the art educator can craft successful scoring schemes and procedures that are appropriate for his or her own performance tasks and program.

Chapter 5 introduces another major category of assessment strategies: informal and formal formative strategies. Informal and formal formative strategies provide ongoing information about student progress and seldom require a grade. Currently, there are many experts in the field of assessment who believe that for the sake of both improved teaching and assessment, all assessments should be formative in nature.

Notes

1 E.S. Hartung, "The Student Critique and Its Diversity" (paper presented at the Four Corners States Art Education Conference, Phoenix, AZ, November, 1990).

2 R.J. Marzano, D. Pickering, and J. McTighe, *Assessing Student Outcomes: Performance Assessment Using the Dimensions of Learning Model* (Alexandria, VA: Association for Supervision and Curriculum Development, 1993) p. 35.

3 M. Van der Kamp, "Self-Evaluation as a Tool for the Evaluation of Learning Outcomes," *Studies in Educational Evaluation* 10 (1984): 265–272.

Chapter

5

Formative Assessment

At its best, classroom assessment blends seamlessly with teaching for the purpose of learning. It neither disrupts nor disjoints the instructional process. If likened to a weaving, then, knowledge of world and self is the warp through which various fibers of teaching and assessing, the weft, are tightly woven. The result is learning—a work of art with rich colors, textures, and patterns unique to each student. The teacher structures the weaving process, views the work as it evolves, collaborates in the final design, and assesses the finished piece.

In general, teachers depend on two broad categories of assessments to give them the information they need to monitor both their own teaching techniques and what their students are learning: *formative* and *summative* assessments. The terms *formative* and *summative* refer more to the purposes for which an assessment is used than they do particular types of assessments. An assessment strategy used during a course of study, in an informal manner, for diagnostic purposes, and, with little or no emphasis on recording scores, marks, or notes, can be defined as *formative*. A *summative* assessment strategy, on the other hand, is used at the end of a course or segment of learning, for the purpose of summarizing what students know and are able to do, and in conjunction with set task dimensions, criteria, and scoring strategies.

In other words, depending on *when*, *how*, and *why* they are used, many of the assessment strategies described in Chapters 2 and 3 can serve either formative or summative functions. Occasionally, an assessment can be *formal* (requiring time for students to complete and resulting in a score that may be recorded) and still be considered formative. This is because the teacher uses the assessment to help monitor or guide student progress.

Spontaneous, informal, quick but meaningful assessment—formative assessment—is a technique art educators regularly use to gather information about student learning, their own teaching, and what additional instructional materials and activities they might need to employ. Because formative assessment is such an essential component of quality classroom teaching, this entire chapter will be devoted to explaining it in detail.

Implementing Formative Assessments

Generally speaking, formative assessment monitors the flow of the instructional process. Formative assessment can be used in all four visual arts disciplines to assess learning in the cognitive, affective, and psychomotor domains. It can focus on processes or products and be either individualized or given to the class as a whole.

Some formative strategies in which the teacher examines group achievement and needs do not even require a student's name. Another use of formative assessment is to determine the status of students at a particular time, for example, at the beginning of the school year; and the quality of their achievement at that point. For such "sizing up" purposes, the art educator can use additional sources such as instinct, intuition, and practical knowledge to form a general opinion about a student's status.[2]

Implementing Formative Assessments: Seven Steps

1 Identify teaching objective.
2 Write a single, assessable question.
3 Select an informal feedback strategy.
4 Decide how to introduce the strategy.
5 Apply the strategy.
6 Analyze and interpret the feedback.
7 Respond to results.

—Angelo and Cross[1]

In order for formative assessment to be successful in the classroom, the art teacher needs to follow seven steps:[3]

1 Identify a teaching objective to assess, related to one of the following:

- discipline-specific content
- discipline-specific processes
- core-thinking skills or cognitive processes
- student attitudes, motivations, values

2 Write a single, assessable question pertaining to the objective.

For example, "What are examples of artworks that could be described as Expressionist?"

3 Select an effective informal feedback strategy or technique.

First, imagine what successful feedback would look like. Then, craft a strategy most likely to elicit the desired information. Formative strategies can include informal oral activities such as conversations with students, questioning students during instruction, or student interviews; pencil-and-paper techniques; or, alternative methods such as questionnaires and journal entries.

4 Decide how to introduce the strategy and fit it smoothly into the lesson or classroom activity.

Consider how much time to allow for the strategy. Remember that formative strategies can occur at any point in a lesson or unit of study.

5 Apply the strategy.

Be sure that students understand both the assessment procedure and what kind of feedback is expected.

6 Analyze and interpret the feedback.

To analyze the information, use both quantitative and qualitative approaches. *Quantitative methods* answer the questions "how many" or "how much" by measuring, counting, categorizing, and comparing amounts, numbers, and proportions. *Qualitative*

Terms to Know

bipolar adjective scale A verbal scale that uses adjective pairs for rating.

qualitative methods Assessment methods that place emphasis on gathering rich and thick descriptive information, such as that gleaned from a teacher's anecdotal record.

quantitative methods Assessment methods that place emphasis on gathering information that is easily quantified or given numbers for scores.

Assessment Hint

Prior to using a particular technique with your whole class, you might want to try it out on a single student or share it with another teacher in order to be sure the technique will give you the kind of information you want.

Assessment Hint

Try using 3 x 5" note cards as a way of administering formative assessments. Consistently using the same color note card, for example, orange, alerts students that some form of formative assessment is about to take place. The small card size also ensures brief and simple student responses. Many card strategies would not require students to sign their names. Note cards can be quickly collected and easily analyzed by simply sorting like responses.

methods answer the questions "what kind," "what ways," or "how well" by narrating, explaining, and giving examples.[4] Even though the educator's tendency often is to gloss over what is progressing smoothly and focus on problems, make an effort to give equal attention to positive and negative feedback. Often the analysis is not about individual student responses, but rather the classroom as a whole.

7 Respond to the results.

Inform students of the outcomes of the formative assessment and explain what the results will mean to them and to the teacher. If a change in instructional strategies or program is merited, the teacher should initiate such action.

Formative Assessment Strategies

Because formative assessments are so well-suited for assessing a wide variety of topics, the sample strategies that follow are divided into four categories reflecting four different kinds of learning that educators might want to assess: Discipline-Specific Content and Knowledge, Discipline-Specific Processes, Core Thinking and Cognitive Processes, and Student Attitudes and Dispositions. A fifth category is concerned with collaboration and cooperation processes. These formative assessment strategies can be adapted by the art educator for use with different age groups. With elementary children, for example, many can be administered orally as a class discussion.

Assessing Discipline-Specific Content and Knowledge

The art educator needs to know what content students are learning in each of the four disciplines. In addition to the simple recall of information, educators also want to know what students view as the most important information learned. Because of the many demands placed on art teachers, simple and easy-to-implement methods for gathering meaningful information for immediate feedback and reteaching are essential. In their book *Classroom Assessment Techniques*, Angelo and Cross (1993) have devised numerous techniques that meet these requirements. In Assessment Strategies 38–42 are several examples, some of which are based on their work.[5]

Assessment Strategy 38
Half-Minute Note Card

This is a quick strategy, implemented within a half-minute time period. The purpose of this assessment is to learn not only how students synthesize information but also what information they perceive as most valuable.

Students are given one half-minute to write (1) the most important thing they learned during class and (2) what crucial question still needs to be answered. Names do not need to be written on the orange cards. *Half-Minute Note Cards* can be used as a warm-up or wrap-up formative assessment and can relate to homework, field trips, lectures, group work, or class activities. After students turn in their cards and the teacher reviews them, a few minutes of class time should be set aside for feedback.

Assessment Strategy 39

Muddiest Point

Ask students to answer the following question on an orange note card: "What was the muddiest point of the lesson, the subject, or the reading assignment?" Suggest that students form small groups to discuss their responses. Encourage students to share the points they found "muddy," to add missing information, and to clarify misinformation and misunderstandings. At the beginning of the next class, ask representatives from several groups to share examples of muddy points, to explain why they were muddy, and to summarize what information shared by group members helped to clarify these points. The teacher should address any muddy points students were unable to clear up themselves.

Assessment Hint

A variation of *Muddiest Point* is *Clearest Point*. As the title suggests, this strategy provides a snapshot diagnosis of what students understood well.

Assessment Strategy 40

Most Note Card

Another way for students to reveal what information they recall and what information is of most signifcance to them is through use of a Most Note Card. *This technique, like the* Half-Minute Note Card, *can be implemented at any time and is focused on actual student learning outcomes from various instructional experiences.*

Ask students to write their response to the following root question on an orange card:
What is the _____ that you have learned in this lesson? Give a reason.

Possible prompts include:
- most important idea
- most disturbing idea
- most significant point
- most unforgettable artist
- most appealing theory
- most surprising information
- most powerful image
- most memorable fact
- most convincing argument
- most successful inch (of an artwork)

Assessment Strategy 41

Three-Person Dialogue

Three-Person Dialogue *is an interactive technique that provides additional data on what important concepts, figures, theories, or ideas students recall and which they see as most significant. Each student works with two others to complete the assessment. The strategy works best when students use a blank sheet of notebook paper. For use in art production activities, encourage students to make sketches, adding labels or notations for their responses.*

Ask each student to write three words or phrases that represent the most important ideas, concepts, or points in the lesson or other segment of learning. Have students write one concept at the top of the page, another in the center, and the third toward the bottom, leaving enough room below each concept to write a paragraph about it. Students then choose one of their concepts and, in the appropriate blank space, summarize its meaning and significance. Encourage students to keep their responses brief and to the point.

Once students have completed this phase of the activity, ask them to pass their paper to the next person, who will choose one of the two remaining concepts and write his or her own summary. Ask students to pass the paper, this time to a third person for remarks about the third and final concept.

Each student is responsible for writing three short paragraphs about three key concepts. If a student is unable to respond to a word or phrase, has already written on the same idea or does not believe the concept is central to the lesson, then he or she can either state as much or pick another relevant concept to discuss.

Papers are then returned to the originator of the words or phrases. Suggest that students take several extra minutes to respond, with dialogue notes, to the answers written by other students on their papers. The teacher might want to hold a short class discussion about students' words or phrases and responses before collecting the papers. To analyze this material, the teacher, working from a prepared master list, examines whether words or phrases selected by students are indeed the most relevant and whether the information described or presented about them is accurate and significant.

RDQC2 *is a final strategy for assessing recall of discipline-specific content and knowledge. This strategy also examines other skills, such as sum-marizing, analyzing, evaluating, and synthesizing. Many students particularly enjoy the interactive aspect of this activity. Not all steps need to be carried out at one time. The technique is most effective when implemented at the end of a class period if classes meet daily, and at the beginning of a class period if classes meet several times per week.*

RDQC2 *stands for Recall, Describe, Question, Connect, and Comment. Working in pairs or groups, each group is responsible for carrying out one step of the process. A group's activity should not take longer than two or three minutes. Group 1 begins by making a list of the most significant concepts or ideas they can recall from the lesson or last class period.*

Then, they rank these concepts in order of importance and share this information with the remaining groups. Group 2 writes a brief description of each concept or idea on the list. Group 3 writes several key questions that remain unanswered about the concepts or ideas or any other important ideas not broached by Group 1. Group 3 also looks for major omissions or errors in the list. Then, Group 4 makes a connection between the listed concepts and lesson or course objectives. Finally, Group 5 makes several evaluative comments about the learning segment or class period such as, "What we enjoyed most/least was _____" or "What we thought was most/least useful was _____" or "We felt _____ about the lesson or last class period." Omissions, errors, and additions are checked by the teacher or the students themselves from a prepared master list of important points and summaries.

Assessing Discipline-Specific Processes

One of the most direct ways to assess discipline-specific processes is to ask students to keep a step-by-step record of their own processes as they create an artwork, write an art-related paper, or create other kinds of art-related projects. The record provides the art educator with a wealth of information about students' work habits as well as their problem-solving skills in art. Teachers might suggest that students document their processes step-by-step in their journals as they work. They can also note the approximate time spent on each step. When the project is completed, give students a list of cognitive processes that relate to the art discipline being assessed (as described in Chart 1, page 132) and suggest that students compare and attach corresponding labels to their own processes. Examining students' personal work processes, in conjunction with an evaluation of their final products, will reveal which steps in students' processes were faulty or insufficient.

A step-by-step analysis of processes should be included as an objective for one art assignment (particularly in art production) and as an assessment criterion for that particular art production task. By stressing a recorded process on at least one occasion, the art teacher will help students become more aware of the importance of developing their own art problem-solving processes rather than focus exclusively on products.

The formative strategies that follow are based on the discipline-specific processes listed in Chart 1. Because of the informal structure of formative evaluation, the art educator will not find designing other, similar strategies difficult. The strategies are listed under discipline headings.

Aesthetics

Assessment Strategy 43
What Puzzles You?

This strategy assesses students' abilities to puzzle and question, a skill many believe begins philosophical inquiry, as well as to recognize underlying principles/rules/concepts/structures.

Ask students to work in groups. Give students a thought-provoking newspaper article describing an art issue. The class can work with the same article or the art educator might give different articles to each group. Ask students to make a list of all the aesthetics-related questions or ideas that puzzle them.

Appropriateness of the list to the article is examined by the teacher. To extend this task conceptually, ask groups to identify factors they would need to know to be able to solve or answer the puzzling questions.

Assessment Strategy 44
Disprove a Theory

Disproving a common aesthetics theory, which is shown as an example of a novel written project in Chart 4 (page 139), can also be used to reveal how students develop and analyze arguments. Group work is particularly helpful for implementing formative assessment strategies in aesthetics, as this discipline is new to many students.

Working in groups or pairs, ask students to select an aesthetics theory they wish to refute. To disprove the theory, students should give an oral presentation with examples of artworks or circumstances that do not fit the case. They should also present information about other theories they believe more accurately apply. The teacher looks for ability to recognize a faulty theory, knowledge of other aesthetic theories, a solid argument presenting several major points, and supporting visual or written evidence.

5.1 Julio B. Montesinos, Niños. *Acrylic on canvas, 72 x 47 1/2" (183 x 121 cm). Private Collection, Cuenca, Ecuador.* Niños *is an example of poetic realism. Therefore, the painting could be disproved as fitting within the mimetic or imitationalist theories of art.*

Art Criticism

Three processes critics use in their work are (1) characterizing, (2) seeking evidence and counterevidence, and (3) presenting a written position or argument. Assessment Strategy 45 assesses students' abilities to demonstrate these processes.

Assessment Strategy 45
Characterizing

Characterizing, defined as distinguishing the features or characteristics of an artwork in a personalized way, is an important component of good art criticism. Examples of characterizing in art criticism follow.

- "The whole looks like a snapshot of the Ice Age."[6]
- ". . . colors are like bugle calls—echoing, responding, now clear, now distant".[7]

From a stack of small art reproductions (postcards or images cut from journals and mounted on cards), students select five images. Ask students to write, on an orange card, a characterization for each artwork they have chosen. Slides or color transparencies can also be used as stimulus materials. Appropriateness to the image, significance, descriptive quality, and creative self-expression are criteria the teacher or students examine.

Art History

Art historians observe, classify, and compare and contrast in order to give meaning to artworks under consideration. Students at the elementary level, particularly those in the early stages of aesthetic development (stages one, Favoritism, and two, Beauty and Realism), are interested in the subject matter and formal characteristics of artworks.[8] Art-historical instruction at this level should address these concerns.

Assessment Strategy 46
Observation Game

The Observation Game, often used as a teaching or motivational activity, can be used as an assessment technique as well in that it reveals students' awareness of subject matter and compositional concerns.

Show students an original artwork (or a slide) and give them a set time, five minutes for example, to study it carefully. Then remove the image and ask students to write on an orange card as much as they can remember from their observations. The teacher might designate specific categories for observation, such as subject matter, elements and principles, and artist's style, and ask students to look for information about these as they observe. For very young children, the teacher might want to conduct this activity orally.

Classifying artworks according to modes, media, artists, genres, styles, and artistic periods are common practices in the art classroom. Art educators often engage students in sorting postcard reproductions in game-like activities. When two different art images are displayed, students can practice comparing and contrasting skills. This strategy describes a game that has both teaching and assessing applications. The game requires students to classify, compare and contrast, and justify reasons.

Select one player to be the Banker, who controls the tokens and also approves all game responses. Three different tokens are used—blue, red, and yellow—with blue representing the highest value. The remainder of the students are players.

Place a "deck" of postcard art reproductions on the table, with images face-down. Use a set of reproductions including examples of decorative arts, folk arts, industrial arts, and art from different historical periods and cultures.

Each player draws three reproductions. The first player must find a "pair" among the three. Pairs can be made in many different ways:

- same elements, for example, the same color blue or type of lines
- same principles, for example, creating unity by use of similar shapes
- same artist
- same art-historical style
- same time period
- same art mode or media
- same technique, for example, strong brushstrokes
- same motif or design, for example, a decorative floral or diaper pattern
- same subject matter or theme
- same purpose or function
- same feeling or mood
- same problem or issue
- same philosophical stance about art

Whenever a player sees a relationship between two images, he or she must give a good reason for the pairing. The Banker approves each reason. For each good explanation as to why two art objects are classified as a pair, the player is awarded a yellow token. Two different reasons are awarded a red token, and three different reasons are given a blue.

Once a pair is made, students place the pair aside and out of play, and draw two more cards. If a student cannot make a pair, then he or she passes to the next player. Students always work from a hand of three postcard reproductions. The student with the highest value of tokens and the most pairs laid down is the winner.

Whatever content the art educator wishes to see students classify or order can be adapted for this game. *Pairs* can be used to assess learning in all four art disciplines. A variation of *Pairs* would be to ask students to give reasons why two art objects are not a pair. Games work very well as both early sizing-up strategies and ongoing evaluation techniques. (Students who initially pass because they are unable to make a pair, generally fare better the next time around, after hearing other students' responses.)

Art Production

My Ideal Solution

Artists often mentally envision their finished product and direct their working processes toward achieving that goal. In short, they intuitively select criteria for solving possible problems. This strategy assesses students' abilities to select appropriate criteria for solving visual problems.

Before they begin working on an art-making task, ask students to close their eyes and envision their ideal final product. Then ask students to list on an orange card or illustrate in their art journal criteria they think might lead to a successful solution of the task. Criteria might include appropriate subject matter, feeling or mood, composition, emphasized elements and principles, color palette, and other related artists or materials that might be explored for help in completing the task. Ask students to rank their criteria based on probable importance to resolution.

When students have completed their artwork, ask them to return to their original list of criteria and determine which criteria were, in fact, of most benefit in actually solving the problem. Suggest that students use scaled responses—"very important," "important," and "not important"—to rate their criteria. The teacher looks for a high correlation between original ranking and scaled responses.

Assessment Strategy 49
Generating Ideas

All artists engage in the process of generating ideas for an artwork. Students can demonstrate their ideation skills with the following strategy. The matrix design is based on a given theme or tasks, and cells are filled with possible conceptions of artworks. The teacher examines fluency, strength, and appropriateness of ideas in relation to the required theme.

Students create a 3 x 3 matrix showing at least nine possible ideas for resolving a task or theme, for example "Collections." They select art modes of their choice for solving the problem and write those as headings for the vertical columns, such as "painting" or "sculpture." Students may also decide to have the same mode in all three columns, which means they would be focusing all their ideas on that one mode. Horizontal rows indicate subject-matter options, such as figurative, genre, landscape, non-objective, still-life, realism, conceptual, and the like. If the student prefers to only work with still-life subject matter, for example, then all three horizontal headings could have that label. Students describe or sketch ideas appropriate to each cell's specification.

Art Preconceptions/Misconceptions

This strategy is designed to reveal preconceptions and misconceptions about art that might hinder learning. It also helps students distinguish between fact and opinion, a process important to both art criticism and aesthetics.

Before introducing a lesson or unit, ask students to write a response to the following question on one side of a note card: *"What is a belief or understanding you hold about_____" (a concept, issue, or technique central to the upcoming lesson or unit)?*

When students have answered the question, divide them into small groups to discuss their answers. Cards can be exchanged if desired. Give all groups these additional questions to answer: *"Where did your answer come from? How did it originate?"* Students must give reasonable explanations for their answers and distinguish between statements of fact and statements of value. Ask groups to share their findings with the class, placing particular emphasis on the answer to the last question.

At the conclusion of the lesson or unit, ask students to write responses to the following additional questions on the back of their cards: *"What misconceptions did you have about material we covered in this unit?"*

"What caused you to change or correct your previous thinking?"

"What beliefs do you now hold about the material covered in this unit?"

"What have you learned about your art preconceptions and misconceptions?"

Strategies for Assessing Core Thinking and Cognitive Processes

In the last decade, interest in studying and learning processes, including cognitive processes and behavioral skills, has surged. Models of instruction are being developed that address cognitive processes, and assessment practices, worldwide, are attempting to measure these processes and skills.

A case in point is Queensland, Australia. All disciplines in the secondary curriculum, including art, are required to develop curricula that encompass core thinking skills identified as central to the discipline. Seniors are tested on these skills with test items stemming from every discipline. (The list of skills in Appendix A, page 131, is derived from Queensland's assessment initiative.)

Because art students regularly practice thinking in critical, philosophical, historical, and productive modes, the art program can be an integral part of assessing cognitive skills. A single thinking process, significant to a particular lesson, might be chosen to assess using a formative strategy. Becoming aware of students' cognitive processes and behavioral skills and targeting one (or several) to assess periodically means that the art educator is probably putting this knowledge into practice during teaching.

Paraphrasing

Paraphrasing is a critical-thinking skill with importance to the reflective domains, particularly aesthetics. Asking students to clarify their own thinking or that of others by paraphrasing or translating what has been said in different terms or language is helpful for understanding complicated ideas in aesthetics. During a discussion, give students a minute to paraphrase (on an orange note card) an important idea or theory that has been raised. Separate journal pages can also be reserved to write paraphrasing

examples related to important topics from readings or from discussions.[9] Periodic review by the teacher of paraphrasing entries enables monitoring of this cognitive skill.

Application Cards[10]

To assess students' abilities to connect new information with prior knowledge, pause after raising an important concept and ask students to write at least three different applications of the concept on an orange note card.

Sorting

Grouping, ordering, and categorizing are classification processes and lower-level reasoning strategies. Art educators can assess this knowledge readily when students sort, group, order, or categorize post-card size reproductions by stylistic periods, artists, media, and the like. Sorting examples of art-related statements into categories of "statements of fact" and "statements of value" enhances student learning in criticism and aesthetics as well.

Asking students to sort principles, theories, or beliefs can be more challenging. For example, art-historical inquiry questions can be sorted into categories of intrinsic and extrinsic methodology; assertions of various aesthetic theories into theory categories; and excerpts of written art criticism into stages of a critical model.

Grids or matrices are useful tools for categorization work. Requiring students to fill in empty cells with their own responses to category headings, give reasons for their cell choices, and induce category headings from a set of responses can strengthen students' categorizing skills. Keeping a supply of empty grids on hand is helpful for sorting activities.

Art Analogies

Art Analogies reveals students' abilities to see relationships between two concepts or terms. The strategy also discloses creative thinking and synthesizing abilities. This strategy works particularly well with content material in art history, art production, and aesthetics.

The teacher gives students a stem and they must complete the analogy. Once students are familiar with the format, encourage them to create their own analogies. The journal is an excellent tool for writing and collecting analogies.

Pointillism is to Seurat
as _____ is to _____.

Short, choppy brush strokes are to Impressionism
as _____ is to _____.

Realism is to the Mimetic Theory
as _____ is to _____.

Assessment Hint

With younger children, try developing a set of art analogies that includes questionable or incorrect responses. Ask students to work in groups and together sort examples into piles of "good," "maybe," and "wrong." Ask groups to give reasons for their sorting decisions. Then, ask students to try writing their own analogies.

Chain Notes

Formative strategies can be designed to examine metacognitive processes as students work in class, on homework assignments, or as part of other assessment strategies. Chain Notes *is a technique that focuses on what is happening during class activities.*[11] *This adaptation of the original Angelo and Cross example is designed to assess metacognitive and conditional knowledge skills.*

Questions are placed inside a large brown envelope. As students are working on their art products, the envelope is circulated around the class. Students draw out a numbered question and respond to it on orange note cards. The number of the question needs to be written on the card. Both question and answer are placed back inside the envelope when finished, and the envelope is passed on to the next student, who draws out his or her own question. Students are encouraged to be brief but thoughtful in their comments. When all students have had an opportunity to respond, the envelope is returned to the teacher. Samples of questions for assessing metacognitive skills are:

- What are you learning at this moment about your artwork?
- What connections are you making at this moment between your work and other art-works, art-related ideas, or life in general?
- What are your next three possible plans concerning your artwork?
- What possible resource will you use next to help you with this artwork?
- What do you think about your working process at this moment?
- Are you considering or using any information that you have gained from feedback from the teacher or students at this moment?
- Have you evaluated something about your artwork in the last fifteen minutes? What is an example of your self-evaluation process?
- What is your level of commitment to this artwork?

Chain Notes can focus on discipline-specific processes as well. Questions can be written and circulated that address the inquiry processes central to writing a critical review or historical report or to making a particular work of art.

Metacognitive Skills

Metacognitive skills are a cluster of complex skills that refers to an awareness and understanding of one's self as a learner and to monitoring, regulating, and orchestrating one's own thinking processes with respect to achieving goals and objectives. Particular skills identified with metacognition are:

- awareness of own thinking.
- ability to make effective plans.
- awareness of and ability to use necessary resources.
- commitment to task regardless of personal liking or enthusiasm.
- ability to control the attention needed for completing a task.
- ability to monitor own thinking and progress.
- sensitivity toward feedback.
- ability to evaluate own thinking and progress.[12]

Assessment Strategy 53

Find the Problem/Questions

The assessment techniques described here offer practice in problem recognition. This formative strategy has applications for all four art disciplines.

The teacher gives an art-production task assignment. An example of student work responding to the same or a similar task is shown to the students without any teacher comments regarding its quality, success, or failure. Working in groups, the students must determine the problems they see with the art object. Students also recommend solutions for the problems they pinpoint. The teacher notes which groups are able to diagnose problems and offer the best solutions.

In aesthetics, students are divided into groups, and each group is given a newspaper or journal article, a teacher-prepared case study, or an aesthetics puzzle dealing with art issues. Groups must find the issue, and identify the questions surrounding the issue. If students are given a published case puzzle to diagnose, like those from the book *Puzzles About Art,*[13] then all questions accompanying the puzzle are deleted to enable students to discover their own.

Asking students to pinpoint problems related to a task or project assesses their skills in diagnosing problems. By recognizing the questions or procedures that guide research, students enlarge their problem-solving skills. Students with good metacognitive skills easily identify problems and underlying questions and principles; this, in turn, enables them to absorb new knowledge more rapidly. Once problems have been diagnosed, students can offer appropriate solution routines.

Strategies for Assessing Student Attitudes and Dispositions

Students' attitudes, dispositions, motivations, and anxieties either help them become more efficient and effective learners or hinder the learning process. These behaviors are frequently described as student internal support strategies. Weinstein and Meyer (1991) maintain that students can be taught to control their internal climates through self-regulation, monitoring, and stress-reducing strategies.[14] An important part of structuring an art program should be to gather information about students' support strategies.

A quick journal entry or probe regarding students' general attitudes and emotional states about an art task or lesson is one means of assessing support strategies. A second easy technique can take place during the last minutes of the class period. Write on the chalkboard simple rating scale anchors such as "Very," "Somewhat," "Not Very," and "Not at All."[15] Ask students to write on an orange note card the response that best fits their feelings toward a series of questions the teacher asks about motivation, anxiety, interest, and so forth.

Find the Art Historian's Questions

In a variation of the Find the Problem/Questions *strategy (page 97), appropriate to art history, students are asked to identify the underlying inquiry questions asked by the historians in their article. This strategy enhances students' abilities to understand a method of inquiry in art history as well as how research questions are explored in art-historical writing.*

From an art history text or a monograph about an artist, the teacher selects a passage about an artwork for students to read. The teacher takes care to match the complexity of the written text to his or her students' capabilities. Students then compile a list of the questions addressed in this example of historical research.

For young students who are able to read, the sample should address the most basic questions of art-historical inquiry, such as: *Who did the work? When and where was it done? What is the medium? What are the characteristics of the artist's personal style?* The following excerpt would work well with younger students:

Sixteenth-century German artist Albrecht Dürer developed his powers of seeing to such a high degree that he was able to reveal to others the wonder of an ordinary patch of wild plants. His watercolor painting, appropriately titled Great Piece of Turf, *shows a commonplace subject seen as though for the first time. Such careful observations of nature helped initiate the development of modern science.*[16]

5.2 *Albrecht Dürer,* Great Piece of Turf, *1503. Watercolor and tempera on paper, mounted on cardboard, 16 x 12 1/2" (40.3 x 31.1 cm). Graphische Sammlung Albertina, Vienna. Photo: Art Resource, New York. © Photograph by Erich Lessing.*

Assessment Strategy 56 shows a third technique for gaining information about student attitudes. The *Attitude Scale* is an example of a *bipolar adjective scale*, that is, a verbal scale with adjective pairs for rating an object.

Assessment Strategy 55

Plan of Attack

Plan of Attack *is a strategy that requires students to create a design for solving a visual problem. The technique reveals students' abilities to make effective plans and to analyze and evaluate their plans with respect to problem solution. An additional benefit of this strategy is that students become aware of different approaches for solving the same problem.*

After an art task has been assigned, students are given a few minutes to write on an orange note card the steps or procedures they plan to use to complete the task. The teacher collects the cards. A short class discussion of the pros and cons of sample plans follows. Cards are returned to the students for revision if desired. When the art assignment is completed, students review what they had previously written on their cards and reflect on the relationship between their proposed plan of attack and what they actually did. They then determine which steps in the plan were most and least successful and give reasons explaining any changes they made to their original plan.

Assessment Strategy 56

Attitude Scale

Together, teacher and students create a list of polar adjectives that describe attitudes, motivations, anxieties, commitment, pride, self-confidence, and similar emotional states. Students are to place an X in one of the five spaces to indicate the extent to which each adjective describes the art lesson or subject in question. Points 1-5 may be assigned to each space on the scale if desired, with 5 representing the most positive response.

Poor	__	__	__	__	__	Good
Exciting	__	__	__	__	__	Boring
Effortless	__	__	__	__	__	Challenging
Pleasant	__	__	__	__	__	Unpleasant
Stressful	__	__	__	__	__	Enjoyable
Hard	__	__	__	__	__	Easy
Worthless	__	__	__	__	__	Valuable

Blank scales (with or without the evaluative dimensions) can be kept on hand for quick and easy assessment practices. After several assessments of art lessons or the course in progress, the art educator has data for making generalizations about students' attitudes toward art learning.

Assessment Hint

To discourage students from selecting one particular end of the spectrum, either positive or negative, repeatedly mix up the placement of negative and positive adjectives.

Strategies for Assessing Student Collaboration
and Cooperation

Assessment Strategy 57

Collaboration Assessment

Collaboration can also be assessed by formative strategies. In the example shown here, the teacher analyzes the number of times collaboration occurred and determines its qualitative dimensions vis-à-vis student responses.

Before beginning a new art assignment, students are asked to keep a record of their collaborative process on an orange card. The following information is noted:

1 How many times did you ask for help, receive help, or collaborate on your art project? Please keep a tally record. Label each mark with the initials of your collaborator.

2 With whom do you collaborate the most?

3 Who contributes the most information in your collaborations?

4 What is the nature of the collaborations?

5 Did you revise or rework your project each time you were helped? Explain.

6 Describe several ways in which collaboration improved your work.

7 Rate your general attitude toward collaboration using the following scale:

I believe collaboration with my teacher and class-mates to be:

___ extremely helpful

___ very helpful

___ somewhat helpful

___ not very helpful

___ not helpful at all

Assessment Strategy 58

Cooperation Assessment

This formative strategy, which uses quality control measures from the business world, evaluates group progress and group cooperation, and gives students opportunities to practice their group assessment and management skills.

When students work in groups, a leader (or executive board) is selected to be the Quality Control Spokesperson(s). The leader or board meets regularly with the teacher to give five minute reports on the following:

• group achievement, activity during and outside of class by members

• group behavior, how well the group is working together

• group participation, members who participate most of the time and are fully prepared for meetings, tasks, or activities

• group maintenance, ability to make changes in group processes and dynamics if necessary

The teacher takes notes during meetings, asks questions, and offers advice when needed. The group is given the power to fire a member, but first must give a written notice indicating problem areas. If the member does not change his or her behavior, then he/she is fired and must leave the group. The person is then "out of work" and must apply for a job with another group, disclosing reasons why he or she was fired.

Using the same procedure, the art teacher can direct group activities toward evaluating the art class, including such things as course materials, activities, and assignments. Students work together to evaluate their classroom experiences and suggest ways to improve instruction. The teacher should be willing to accept criticism and work with the students as they share their concerns.

Formative strategies lend themselves to assessing a wide range of content, processes, skills, and attitudes. They enable the teacher to modify instruction and sharpen the focus of the curriculum. More importantly, formative assessments diagnose students' cognitive strengths and weaknesses early and on a regular basis. The stream of learning flows continuously and swiftly—sometimes turning, sometimes transforming, sometimes reversing—ever changing. Formative assessment catches and analyzes a moment in the learning process, whereby a future course can be channeled.

If indeed, feedback is "the thing that makes it most likely that students will improve later performance effectively and efficiently," then feedback should occur not after assessment, but as students perform.[17] The strength of all formative assessment lies in the opportunity for immediate educational feedback. As such, formative assessment plays an invaluable role in improving education. It is little wonder many educators believe that *all* assessments should be formative.

Notes

1 T.A. Angelo and K.P. Cross, *Classroom Assessment Techniques*, 2d ed. (San Francisco: Jossey-Bass, Inc. Publishers, 1993) pp. 46–50.

2 P.W. Airasian, *Classroom Assessment* (New York: McGraw-Hill, Inc., 1991) p. 14. This is a basic book about tests and measurement.

3 See note 1 above.

4 Angelo and Cross (1993) p. 52.

5 See also Assessment Strategies 51–53.

6 G. Henry, "John Hultberg at Denise Bibro," *Art in America* 82: no. 10 (1994): 140.

7 L. Campbell, "Aristodimos Kaldis at Broome Street," *Art in America* 82.: no. 10 (1994): 138.

8 M.J. Parsons, *How We Understand Art: A Cognitive Developmental Account of Aesthetic Experience* (New York: Cambridge University Press, 1987).

9 See note 1 above.

10 Angelo and Cross (1993) pp. 236–239.

11 Angelo and Cross (1993) pp. 322–326.

12 R.J. Marzano, D. Pickering, and J. McTighe, *Assessing Student Outcomes: Performance Assessment Using the Dimensions of Learning Model* (Alexandria, VA: Association for Supervision and Curriculum Development, 1993).

13 M.P. Battin et al., *Puzzles About Art* (New York: St. Martin's Press, Inc., 1989).

14 C.E. Weinstein and D.K. Meyer, "Implications of Cognitive Psychology for Testing: Contributions from Work in Learning Strategies," in *Testing and Cognition*, eds. M.C. Wittrock and E.L. Baker (Englewood Cliffs, NJ: Prentice-Hall, Inc., 1991) pp. 40–61.

15 Angelo and Cross (1993) p. 276.

16 D. Preble and S. Preble, *Artforms*, 5th ed. (New York: HarperCollins Publishers, Inc., 1994).

17 G.P. Wiggins, *Assessing Student Performance* (San Francisco: Jossey-Bass, Inc. Publishers, 1993).

Chapter

6

Summative Assessment

A gifted Utah student earned perfect scores on both the Scholastic Aptitude Test (SAT) and the American College Test (ACT). He excelled in many areas of the high school curriculum including languages, theater, music, and sports. When asked if he had ever received a final grade less than an A, the young man replied that he had received one B+ grade—in art. For him, visualizing in a variety of different ways was difficult. The summative assessments of his art products resulted in a B+ grade, which in this case, was a significant mark in an otherwise perfect high school academic record.

Although its long-term educational effects on student learning are not as significant as formative assessment, *summative assessment* is often considered more important, primarily because a grade or mark, generally reported to students, parents, and school administrators, is its final outcome. Despite the weight many attach to test or other summative assessment scores, evaluations do not necessarily constitute quality feedback. Such evaluations are important, however, because they lead to curriculum and educational policy changes and, therefore, encourage educational reform initiatives.

Summative assessments are more formal than formative assessments; they require more preparation, cover more content, demand that issues of validity and reliability be addressed, are presented in a more rigid atmosphere, take longer for students to complete, and generally are considered *high-stakes* because important consequences are attached to them. Summative assessments fall into one of two categories: commercially-constructed and teacher-constructed. Even in the art classroom, teachers sometimes use assessments created by textbook publishers or other outside sources. Teacher-constructed summative assessments give the art educator more flexibility and need not be confined to pencil-and-paper formats. Any of the assessment strategies identified in Chapters 2 and 3, such as portfolios, journals, integrated performances, group discussions, exhibitions, visual identification, and tests, can be crafted as summative assessments. In art classrooms, the portfolio is often used for summative assessment purposes.

Assessment Strategy 59 combines a performance and an essay as a summative assessment to follow the study of aesthetic issues. Although the strategy is geared for students with a broad knowledge of

Assessment Strategy 59
Aesthetics Problem

Give groups of three students a package of white lifesavers to share with each other. Instruct students to take several lifesavers from the package and let the candy melt in their mouths for different lengths of time resulting in a variety of sizes. Ask students to stack the different-sized melted lifesavers in a graduated cylinder (one cylinder per group of three students). When students have completed their pyramidal stack of lifesavers, place the stack on a card near each group of three students to allow for easy viewing. Then, ask students to answer the following essay question:

You have just replicated an artwork by Chicago artist Tom Friedman called *Untitled*, 1992.[1] What major aesthetic issues discussed in class can you relate to the object you just created? Please write an essay about this object focusing on four key aesthetic issues pertinent to it. You will be graded on the following criteria:

- knowledge of four major aesthetic issues related to the object (8 points)
- use of references to theories and/or philosophers in the discipline (4 points)
- personal beliefs about the four key issues and the object (4 points)
- organized and interesting discussion (3 points)
- acceptable grammar and spelling (1 point)
 Scoring of the first two criteria will focus on the correctness of responses, and of the third criterion, a compelling and well-expressed argument.

aesthetics issues, it could easily be simplified for younger students by limiting the discussion to one particular issue, such as "What is Art?"

Implementing Summative Assessments

Summative assessments need to be thoughtfully conceived and carefully planned. The Art Assessment Guideline discussed in Chapter 7 (see page 115) is an example to be used primarily for performance-based summative assessments. When preparing for a test, as the method of summative evaluation, the art educator needs to use a different formal plan as a guide, a *test blueprint* or *table of test specifications*.

Generally, the test blueprint is designed in a matrix format, with the behavior or skill to be tested indicated across the top, the content or test objectives on the side, and the test questions described in each cell. Frequency of the questions in each column or row indicates importance or weighting. For an example of a test blueprint see Chart 5 on page 142.

Although creating a test blueprint can be time-consuming, the advantages to both teacher and student make the effort worthwhile. For the student, the test blueprint ensures a more comprehensive and accurate testing implement. For the teacher, it establishes content validity, reveals the emphasis of a given test, allows for easy visualization of the test as a whole, and heightens awareness of the attributes of a good test. For example, studies indicate that the vast majority of teacher-constructed questions assess only the recall of facts and that most teachers find it difficult to write test items that assess higher-order thinking skills such as those listed in Bloom and Quellmalz's taxonomies of cognitive skills.[2] The test blueprint provides a ready-made tool for teachers to use to examine where, in the range of cognitive skills, their questions fall. In the day-to-day classroom

Assessment Hint

If you are new to creating test blueprints, then these tips will help.

- Create only one or two blueprints a year for major tests.

- If possible, work with a colleague to create the basic matrix.

- Use the blueprint as an instructional tool by sharing it with students prior to beginning the unit of study.

- Keep blank matrixes on hand to use as needed.[4]

Assessment Hint

For help writing questions that assess high-level cognitive skills, see Assessment Strategy 16 in Chapter 3 on page 50.
This strategy shows a block of test questions that assesses the breadth of a cognitive taxonomy, lower- to higher-level thinking skills, based on the Quellmalz model.

Assessment Hint

If you are not familiar with creating a scoring rubric, then try working together with colleagues or study examples from other disciplines. For sample rubrics contact your school or district administration.

situation, teachers would need to create a formal test blueprint only for the few tests that weigh heavily in grade consideration.

Scoring the Summative Assessment

Because summative assessments generally contribute to a grade, how they are scored is very important. The Art Assessment Guideline in Chapter 7 includes a step-by-step plan for developing a scoring guide for performance-based assessments (Steps 13 through 17, see page 121). Additional information about scoring summative assessments follows.

If the summative assessment is a pencil-and-paper type of test, then the art educator should prepare an answer key as he or she creates the test items. After students complete the test, items are marked and the correct score is recorded.

If the summative assessment is a performance, then the teacher may need to craft a *scoring rubric*, that is, a formal scoring plan that defines levels of achievement in the horizontal position and assessment criteria in the vertical position. Charts 2 and 3 (page 133–137) show examples of scoring rubrics based on holistic and analytic scoring models respectively. A rubric aids the scoring of a performance and makes scoring more objective and reliable. If the assessment task requires a scoring rubric, then it should be developed in tandem with the task. To create an analytic scoring rubric, use the following steps.

Creating an Analytic Scoring Rubric

1 **Develop Levels and Explanatory Descriptions.** Describe in detail the achievement levels (standards) appropriate to the content or processes of the discipline being assessed. Develop labels for four or five distinct degrees of achievement and describe what each label means with respect to performance in art

production, art history, art criticism, or aesthetics. Examples of labels for which the art educator will write explanatory descriptions include:

- "Novice," "Apprentice," "Advanced," "Superior"
- "Inadequate," "Rudimentary," "Satisfactory," "Competent," "Exemplary"
- "Minimal," "Basic," "Proficient," "Advanced"

Using a matrix, arrange achievement levels across the top, in the horizontal position (see Chart 3). Once level descriptors are determined, they can be used repeatedly across art assessments.

2 Create a Numerical Scale.

Assign a numerical scale to rate each of the four or five achievement levels. For example, Novice Level = 1, Apprentice Level = 2, and so forth. Use these numbers to rate the performance. Later, they can be easily translated into grades.

3 Designate Task Criteria.

Determine what content or processes are to be examined. Content and processes are derived from the discipline; however, cognitive processes, which cut across disciplines, can also be included as task criteria. Arrange criteria in a list in the vertical portion of the matrix.

4 Annotate Each Cell.

Describe each cell in the matrix qualitatively, that is, as it relates to the criterion on the vertical axis and achievement level on the horizontal axis.

5 Score the Performance.

Assess the performance using the analytic scoring rubric. If, after several student performances, the art educator finds that the rubric does not work efficiently, he or she should revise it.

Creating a Holistic Scoring Rubric

The holistic rubric is used to score the product as a whole. Rather than a matrix format, the holistic rubric often resembles a descriptive paragraph. To design a holistic rubric, three or four competency levels are identified such as "novice," "intermediate," "advanced" or "1," "2," "3," "4." Levels are described with more in-depth qualitative information than is common in the analytic model. Frequently, three bands of "1/2," "2/3," and "3/4" are created, with descriptions of each band, to enable greater precision in scoring. The scorer determines upon reading the descriptive paragraph whether the student's work belongs in the "1/2" band and more exactly is a low 2, or whether it belongs in the "2/3" band and is a high 2, and so forth. Because art teachers are used to sizing up the whole product, a well-written holistic rubric may be easier and faster to use than an analytic rubric.

Determine Exit Levels of Achievement

Once the rubric is completed and proven to work efficiently as a scoring tool, the art educator needs to determine exit levels of achievement.

Chart 6 (page 142) shows an example of final levels of achievement.[5] This example is based on the analytic scoring rubric described in Chart 3 (page 134). Exit criteria in the portfolio rubric are Researching, Creating, Responding, Resolving, and Communicating, and the chart makes clear what standards of achievement are needed, pertaining to these criteria, for awarding overall Very High Achievement, High Achievement, and so forth. Students need to be informed of these expectations. Exit levels of achievement can be recorded as grades.

Score Referencing Systems

By itself, a score, such as the number 22 on an art performance or test, is meaningless. The score only makes sense when it is compared or referenced to something else. For example, when the number 22 is referenced against a possible score of 30, then the score, 22, means something. Explanations of two of the more common methods used to compare or reference a score follow.

1 Norm-referencing

Norm-referencing compares or references a student's score on a performance to the performance of a defined group or norm group.[6] Norm-referencing, then, makes comparisons among students. A score is said to be norm-referenced when the art teacher says: "John did better on the art history test than ninety percent of his classmates." Perhaps the most familiar score type for norm-referencing is a *percentile rank*, which indicates the percentage of students scoring below a particular raw score.

Large scale norm-referenced tests do not refer specifically to a particular curriculum, but rather, to sample skills that might be found in a variety of curricula. Norm-referenced tests have a marginal history in visual arts assessment. If the art educator has administered national or state standardized art tests, then such assessments are norm-referenced. Also, when the art educator interprets an assessment score as valid because it is in line with other similar students' scores or because it adheres to a grading scheme based on the bell curve, the art educator is using a simple form of norm-referencing.

The major problem with norm-referenced tests is that they provide little information relative to diagnosis and prescription; they only provide information about the standing of a student in reference to his or her peers.

2 Criterion-referencing

Criterion-referencing compares a students' score on a performance or test to a predetermined criterion of a whole repertoire of behaviors, which are referenced to the content and skills, or domain, of a discipline. In essence, students are not compared to the standing of other students, but to the standard of the criterion, which measures what kinds of things the student with a particular score can accomplish. Criterion-referencing is sometimes called an *absolute scoring system*, because it compares each student's performance to the same performance standard. A score is criterion-referenced when the art teacher says:

John's score indicates he understands with a high degree of accuracy the varied stylistic characteristics of abstract expressionism. He also understands the philosophy and historical context that spawned Abstract Expressionism and can accurately place the art movement in a time frame. John is able to recognize the work of several significant Abstract Expressionist artists and demonstrates understanding of major artistic techniques invented during that movement.

In contrast to norm-referenced tests, criterion-referenced tests can be matched to a particular curriculum. A test can also incorporate both criterion-referenced and norm-referenced scoring, the combination of which reveals both how well the student performs on a criterion and how well that student's performance compares with others. The advantage of a criterion-referenced test is its ability to diagnose and prescribe. Historically, criterion-referenced scoring schemes have been widely used for classroom art assessments; the portfolio, with emphasis on standards for individual achievement, is an example. Educators often refer to criterion-

referencing as *objective-referencing*, by which they mean that the criterion for which assessment tasks are created is related to course performance objectives. In the new vision of assessment, criterion-referencing is a preferred score-referencing scheme.

To sum up, there is no one right or wrong referencing scheme. What matters most is: (1) that the referencing scheme be determined as assessments are developed and (2) that the referencing scheme corresponds to the way the teacher wants to use scores in his or her classroom and to report scores to students, parents, and administrators.

Grades and Marks

A score is derived from a summative assessment, recorded, and combined with marks from other measures to obtain a *grade.* The terms *grades* and *marks* describe a method for reporting student progress that relies on a system of symbols.[7] The numerical scale or category system adopted for use with grades and marks is an example of *measurement.*

Although criticisms concerning the meaning and usefulness of grades abound, most school settings use them as a primary means of reporting student progress. Student progress can also be reported using checklists, parent-teacher conferences, letters to parents, and pass-fail type grading. Some schools use multiple marking systems, such as a report card with a variety of marks indicating both achievement and attitudes.[8] The art educator must comply with the grading policy of his or her school. Within this framework, however, the teacher can do much to make grading a meaningful and accurate indicator that supports rather than impedes student learning.

The art educator needs to establish a personal grading policy that satisfies both school, district, or state-mandated requirements and the needs of his or her art classroom. This grading policy should not be

Assessment Hint

Consider grading attitudes, levels of motivation, attendance, and the like separately from the quality of the product or process. If, however, a painting is not finished or poorly resolved because the student did not work sufficiently during class periods, then the quality of the product and its resulting grade are obviously affected by attitude and motivation.

Art Grading Criterion
How to Develop a Personal Grading System

1 Explain what grades mean.
2 Determine the meaning of failure.
3 Incorporate performance variables.
4 Determine grade distribution.
5 Clarify grade components.
6 Determine how grade components will be weighted.
7 Determine standards.
8 Plan for borderline cases.

at great variance with other teachers' grading policies or with general school policy. To the extent that grading reflects the personal values and philosophy of individual teachers, it is crucial that art educators make every effort to establish a grading system that is accurate and fair. Use the eight criteria listed below as a guide for developing a personal grading system.[9]

1 Explain What Grades Mean.

The art educator needs first to clarify with students exactly what an A, B, or C means. Is an A always ninety percent of objective or learning target achievement? Does an A reflect achievement only or does it also include effort? Is behavior and/or attitude considered when determining an A grade?

2 Determine the Meaning of Failure.

Is failure defined as no learning or a low level of learning? If the student did not follow set criteria or rules for the artwork, then is the work to be considered a failure and graded as such? Invariably, some students will decide to "do their own thing" with little or no regard for particular art criteria. The art teacher needs to consider carefully how he or she plans to handle such situations and to establish a minimum required level of achievement. The student who consistently falls below that level receives a failing mark.

3 Incorporate Performance Variables.

Examples of performance variables relating to art are: time needed to finish work, improvement and growth, safe and proper handling of tools and materials, talent, assistance and collaboration, and motivation. The art educator needs to determine how these variables will affect students' grades. Whatever decision the teacher makes should be consistent with the teacher's policy regarding the first two criteria.

4 Determine Grade Distribution.

Some teachers believe that no student should receive the grade "F." Others believe that "A" grades should be given sparingly. How the art educator (and the school) feels about grade distribution must be addressed.

5 Clarify Grade Components.

The art educator needs to decide and communicate to students which marks will comprise the final grade. Will the teacher set a fixed number or will the number fluctuate in accordance with classroom and/or curriculum needs? What is the minimum number of components that will make up a grade? As the teacher addresses this issue, he or she should consider all classroom assessments and then decide which ones should contribute to final determination of a grade.

6 Determine How Grade Components will be Weighted.

Are certain components of a grade going to be considered more heavily than others in determining the final mark? How will the journal be graded with respect to the art portfolio? Are all artworks considered equal in grading? How does a paper elucidating some aspect of art history compare to an art product? How will the emphasis given to pop quizzes compare to the summative assessment? What about homework and extra credit? How much weight does "best effort" carry? Solidifying ideas about these issues is crucial to establishing a grading policy.

The art teacher might want to use the suggestions below, which list criteria for deciding which components ought to be weighted most heavily, to clarify his or her thinking about this issue. Heavily weighted components:

• show a high degree of relevance to the curriculum and the art disciplines.
• have received instructional emphasis.

- require that students use more thinking processes and skills, and of higher complexity.
- show equity for all students.
- evidence reliability and objectivity, that is, yield greater amounts of information on student achievement in a domain and can be reevaluated with the same results.

7 Determine Standards for Grades.

The art educator should establish standards for assigning grades. What kind of framework will help determine standards? Should grades be determined by *absolute standards*, that is, ascertained by comparing "a student's performance to a defined set of tasks to be done, targets to be learned, or knowledge to be acquired"?[10] Using this framework, students who complete the highest number of tasks successfully receive the highest grades. Or, should grades be determined by *relative standards*, which means that "students performing better than their classmates receive the higher grades"?[11] Some art educators prefer to use *growth standards* as a framework, that is, students performing at or above what the teacher believes them capable of, "receive the better grades, regardless of their absolute levels of attainment or their relative standing in the group."[12]

A cautionary note: growth-based grading can present problems. Although using such a grading framework allows a more individualized approach and meets the needs of special students, it also allows the less capable student to earn the same grade as a more talented student without necessarily completing the same quantity or quality of work. In such a setting, students coming into the class with high levels of achievement often do not make as significant gains as those arriving at lower levels. If the art educator chooses to employ different standards for different students, then how can that decision be made equitable and fair for all? Using too many

Terms to Know

absolute standards Refers to task-referenced or criterion-referenced grading. Using absolute standards, students' grades are based on their performance of tasks, mastery of learning targets, and acquisition of knowledge.

growth standards Refers to self- or growth-referenced grading. Students' grades are based on their performance in comparison with what the teacher believes their capacity to be.

relative standards Refers to group- or norm-referenced grading. Students' grades are based on their performance in comparison with that of their classmates or some other group.

grading frameworks will only confuse the matter. These are not easy decisions for the art educator to make. Use established school policy on grade standard frameworks and issues as a guide.

8 Plan for Borderline Cases.

What about a grade that hovers on the borderline between two grades? Will assessments be reviewed a second time? Will additional information be sought? Should extra work be allowed? Should the teacher seek more specific qualitative information about students' products and processes and/or consider factors such as interest, motivation, deportment, and attitudes? Generally, it is preferable to give a borderline student the benefit of the doubt and assign a higher rather than lower grade.

A Model Grading System

The art educator who wants his or her grading system to address the issues of student differences and special abilities might consider using a three-level grading model, called a *sliding* grading system, which considers effort, progress, and mastery but weights each component differently depending on the level at which the student is working.[13] The plan uses three levels of scoring: (1) novice, (2) apprentice, and (3) veteran.

- novice level: the grade is determined largely on the basis of effort and progress toward predetermined standards. The scoring percentage ratio would be approximately 40:40:20 (40 percent = effort, 40 percent = progress, 20 percent = mastery).
- apprentice level: mastery figures more prominently in determining the grade, with the scoring percentage ratio approximately 25:25:50 (25 percent = effort, 25 percent = progress, 50 percent = mastery).
- veteran level: the grade is determined primarily on the basis of mastery, with the scoring percentage ratio approximately 10:10:80 (10 percent = effort, 10 percent = progress, 80 percent = mastery).

The teacher would annotate each grade recorded in the grade book with an **N** (novice), **A** (apprentice) or **V** (veteran) to indicate level. Students would choose the level on which they are assessed, but are required to move up to a higher level when they have attained a certain grade point average (GPA) at the level in which they are working. Because what differentiates the levels is judging and scoring criteria, the art educator could use either different or the same assessments for each level. Student report cards would be annotated to show level and grade. "N B," for example, indicates Novice level, B grade.

As learned in this chapter, summative evaluation assumes a unique place in the assessment landscape. To students, parents, school administrators, and the public at large it looms in the foreground overlapping formative evaluation. To the classroom teacher more concerned with monitoring ongoing student progress, summative assessments move to the background. If, however, after a summative assessment, the art educator has opportunity to address objectives not achieved, then the summative assessment becomes formative in nature, shifting to a central focus. Summative assessments do enable the art educator to examine the quality of his or her own teaching and determine which lessons or units were successful. A summation of what students have learned in a lesson, unit, or course can help evaluate how well instructional plans worked. In the classroom setting, then, summative evaluation functions as a reform catalyst in that it indicates to the art educator what instructional and curriculum revisions need to be made for the next group of students. Each evaluation approach makes a vital contribution to the overall assessment picture.

Notes

1 Consult critic Wolf Kahn's comments on *Untitled* in the article "Connecting Incongruities" from the November 1992 issue of *Art in America*.

2 See studies confirming this, including M. Fleming and B. Chambers, "Teacher-Made Tests: Windows on the Classroom," in *Testing in the Schools: New Directions for Testing and Measurement*, vol. 19, ed. W.E. Hathaway (San Francisco: Jossey-Bass, Inc. Publishers, 1983) pp. 29–38; and R.J. Stiggins and N.F. Conklin, *In Teacher's Hands: Investigating the Practice of Classroom Assessment* (Albany: SUNY Press, 1992).

3 A.J. Nitko, *Educational Assessment of Students*, 2d ed. (Englewood Cliffs, NJ: Charles E. Merrill Publishing Co., 1996) p. 8.

4 See note 3 above.

5 Board of Senior Secondary School Studies, *Art Senior Syllabus* (Queensland, Australia: 1996) pp. 1–44.

6 See note 3 above.

7 The term *grades* is popular in America, while *marks* is employed in Europe.

8 See note 1 above.

9 Based on D.A. Frisbie and K.K. Waltman, "Developing a Personal Grading Plan," *Educational Measurement: Issues and Practice* 11, no. 3 (1992): 35–42.

10 Nitko (1996) p. 334.

11 Nitko (1996) p. 336.

12 See note 3 above.

13 G.P. Wiggins, *Assessing Student Performance* (San Francisco: Jossey-Bass, Inc. Publishers, 1993) p. 172.

Art Assessment Guideline

Implementation of assessments that carry significant weight for the student, teacher, or art program requires careful planning. The Art Assessment Guideline described in this chapter can help the art educator in this task. The model consists of six major stages with several steps within each stage.[1] Many of the steps can be completed easily as the art educator prepares the assessment. Others may require the art educator to think about assessment in new ways.

Art Assessment Guideline

I. Clarification of the Purpose(s) of the Assessment
Step 1. Describe the rationale or purposes for the assessment.
Step 2. Describe the decisions that will be made based on the assessment.
Step 3. Describe the decision-makers.
Step 4. Describe the examinees (grade levels, numbers, characteristics).

II. Clarification of the Domain to be Assessed
Step 5. Describe the different types of knowledge (content, methods of inquiry or procedures, conditions, metacognitive skills, attitudes) that are central to the domain and might be assessed.
Step 6. Describe key cognate skills of the domain (basic or core, social, technological) that might be assessed.

III. Clarification of the Assessment Task or Strategy
Step 7. Describe the assessment task or strategy (instrument or technique).
Step 8. Describe the products and processes of the assessment task or strategy.
Step 9. Describe criteria and achievement levels (standards) of the assessment task or strategy.

IV. Clarification of the Assessment Task Exercises
Step 10. Describe the specific exercises of the task or strategy.
Step 11. Describe exercise stimulus materials.
Step 12. Describe time, implementation procedures and directives, environment, and protocols needed for the exercise.

V. Clarification of the Scoring or Judging Plan
Step 13. Describe type of scoring (holistic, analytic, combination).
Step 14. Describe scoring or judging strategies (e.g. rating scale, checklist, interview).
Step 15. Describe weighting of the scoring.
Step 16. Describe scorers or raters.
Step 17. Develop a scoring rubric based on assessment criteria and standards.

VI. Clarification of Reporting-Out Plan
Step 18. Describe the receivers of or audience for assessment results.
Step 19. Describe how the assessment results will be reported.

This chapter describes in detail each stage of the guideline and provides practical questions to help the art educator complete his or her own guideline.

I. Clarification of the Purpose(s) of the Assessment

The first four steps of the guideline are intended to help clarify the rationale for implementing the assessment. Generally, the purpose of an assessment is to glean information relative to three broad categories: (1) student learning outcomes, (2) teacher effectiveness, and (3) program effectiveness. Assessments can provide valuable information relative to selection, placement, counseling, and curriculum evaluation decisions as well as feedback to teachers, students, parents, and administrators. Assigning grades or motivating students should never be the sole rationale for an assessment.

Step 1 asks the art educator to describe the purpose or goal of the assessment. The following questions may help:

- Why am I assessing?
- Am I trying to determine if my program goals and objectives have been met?
- Am I trying to monitor overall student progress?
- Do I need the assessment score in order to assign a grade at the end of a quarter or course?
- Do I need corrective feedback in order to help motivate a student?
- Do I need to determine if state-mandated art education content standards are being met?
- Will an assessment score help me to determine into which class, group, or program a particular student should be placed?
- Will the assessment help me to determine how effectively I am teaching?
- Do I need to assess my curriculum for areas which need improvement?

Step 2 encourages the art educator to think about the decisions that will be made as a result of the assessment.

- Will a student's final grade be an assessment outcome?
- Will the curriculum be discarded or retained as a result of the assessment?
- Will assessment results determine a student's advancement in art class? Could it be used to prevent the student's further study in art?
- Will the assessment impact funding or administrative support of the art program?
- Will I be rated on my teaching capabilities as a result of the assessment?

The art educator's answers to the questions in Steps 1 and 2 will determine the type of assessment he or she uses. If a program or curriculum is being evaluated, then both products and processes need to be assessed. If the assessment will determine a grade, then the art educator should consider using both objective and subjective test formats. If a recommendation for advanced art study is at stake, then the assessment should incorporate a variety of strategies rather than a single assessment format. If teaching performance is being evaluated, then numerous qualitative measures should be considered.

In **Step 3** the art educator is asked to identify who the decision makers will be for a particular assessment.

- Who is making the decisions that will result from the outcomes of this assessment? The classroom teacher? School administration? Administrators at the district level? Or key decision-makers at the state level?

If the teacher is the decision-maker, then the assessment should involve all students and address

student learning outcomes and feedback. If state officials are the decision-makers, then a random sample of student performance is probably sufficient.

Step 4 asks the art educator to determine who will be assessed. Matching the assessment to the students is necessary for designing strategies that are feasible and appropriate. Important factors to consider are age, grade level, number, learner characteristics, and special needs. Other questions to consider include:

- What level of students is most appropriate for gathering the evidence sought in this assessment?
- Are the students the art educator has selected for this assessment appropriate? Will assessing these students yield the information sought?
- How many students need to be assessed in order to reach a meaningful judgment?
- What type of assessment format would best fit the level, needs, interests, and learning styles of the students being assessed?

II. Clarification of the Domain to be Assessed

The second stage of the guideline prompts the art educator to give thought to the domain being assessed. The following questions will help clarify **Step 5**, the disciplines and knowledge areas the assessment will address.

- Will the four art disciplines be assessed separately or holistically?
- What discipline content (knowledge of facts, ideas, generalizations, theories) will be assessed?
- What discipline-specific methods of inquiry (knowledge of processes and procedures) will be assessed?
- What discipline-specific conditions (knowledge about when and why certain choices are most appropriate) will be assessed?
- What metacognitive skills (knowledge about one's own thinking processes in a discipline) will be assessed?
- What motor skills related to art (proper handling of tools and materials, craftsmanship) will be assessed?
- What attitudes or affective skills (responding, appreciating, valuing) will be assessed?
- How many of these knowledge types could be addressed in one assessment? Which ones might be easily combined?

Step 6 asks the art educator to describe the key skills that impact the domain being assessed and are, therefore, appropriate assessment criteria. Many core skills are employed in art education activities. These core skills include basic skills, such as reading, writing, oral communicating; critical thinking skills, such as problem setting, analyzing, researching, hypothesizing, and evaluating; creative skills, such as fluency and flexibility; social skills, such as collaborating, working independently, and cooperating; and technological skills, namely computer applications. Sample questions the art educator might ask include:

- In which disciplines are there significant evidence of key cognate skills?
- Which core skills most affect art learning and assessing?

III. Clarification of the Assessment Task or Strategy

Steps 7, **8**, and **9** address the heart of assessment— the assessment task itself. Assessment experts agree that no assessment specification is more critical than Step 9. The art educator must have a clear vision of the dimensions of the task and the meaning of a

good and poor performance of that task. Key questions to consider in steps 7, 8, and 9 are:

- Does the assessment strategy match the purposes of the assessment?
- What strategy will most effectively yield the desired information? A performance? A portfolio? A written test? Art-historical research?
- What is the best evidence of proficiency in regard to the chosen task? Processes? Products? Both?
- Which processes and products need to be examined? Will the selected art product reveal enough information concerning process?
- What strategy will reveal information about students' metacognitive processes? Demonstrate core skills?
- What are the criteria for the task? What are the levels of achievement (standards) required for products and/or processes?
- What criteria will be considered for scoring purposes? Emphasized over others?

If the art educator decides at this point to use a traditional pencil-and-paper test for evaluating student learning, then Steps 8–11, which focus on clarifying performance-based assessment strategies, can be skipped. In this case, if the test is high-stakes, the teacher needs to craft a test blueprint as described in Chapter 6 (page 105) and shown in Chart 5, page 142. Once the test blueprint is designed, the teacher should move to Step 12 of the Art Assessment Guideline and continue as directed.

IV. Clarification of the Assessment Task Exercises

Describing an assessment exercise requires the consideration of several factors: (1) the form of the exercise, which can include both structured participation and observation components; (2) the obtrusiveness

Assessment Hint

Understanding the different knowledge areas, as they relate to the four art disciplines, will help the art educator have a deeper understanding of the structure of the disciplines and which skills are most appropriate to assess. Assessment results of cognate skills can be shared across academic disciplines.

Assessment Hint

Resist the temptation to pick an assessment strategy without prior planning. It is well worth the time and effort required to do the work suggested in the first two stages of the guideline. Doing this work will enable you to determine the appropriate assessment task, its dimensions and products, and the criteria for judging.

of the exercise, that is, how much of the exercise will be known to students and how much will be observed by the teacher unobtrusively; (3) the amount of evidence that will be gathered; and (4) the number of exercises needed to understand students' knowledge of the concept, object, or process being assessed.

Step 10 asks the art educator to clarify exactly what form the exercises will take. **Step 11** requests the materials needed to complete the task. **Step 12** requires explanation of specific task directives, such as time allotted, implementation procedures, and rules. If, for example, the art assessment task will be original or generative art-historical research, then questions that might help clarify the exercise include:

- How will art-historical research be defined? What is the nature and format of art-historical research?
- How will art-historical research be reported and presented? An illustrated report?
- What kinds of art-historical problems are acceptable? Will students be shown examples?
- How much evidence will be required?
- What materials will students need to carry out the task? Where will research be conducted?
- How much time will students be given to complete the task?
- Will group work be permitted or must students work individually How will the teacher assist?
- Will observations of students as they conduct research be part of the exercise? If so, how will the task be observed?
- What additional administrative constraints need to be considered?

V. Clarification of the Scoring or Judging Plan

Performance-based assessment tasks require a carefully-considered scoring or judging plan. The scoring plan should be developed in tandem with the task itself, as problems with the task often surface when the art educator attempts to describe the scoring plan. The following questions will help the art educator address **Steps 13**, **14**, **15**, **16**, and **17**.

- Will the scoring be holistic, with an overall score for several different dimensions; analytic, with a specific score for each dimension; or modified holistic, using a combination of both approaches?
- What will be the scoring or judging strategy? Rating scale? Checklist? Interview? Scoring rubric?
- If a scoring rubric will be used, then what kind of rubric does the task require? A holistic rubric? An analytic rubric? A combination of both rubrics?
- What type of score will be given? Numerical? Alphabetical? Visual graph? Verbal?
- What will be the weighting of scores?
- Who will score the task? Does the rater need training?

Step 17 requires that the art educator develop a scoring rubric, if one is appropriate for the selected task. The rubric is based on the information provided by the answers to questions asked in Steps 5, 6, 10, 13, 14, 15, and 16. See Chapter 6, page 106, for a step-by-step procedure for developing a scoring rubric.

VI. Clarification of the Reporting-Out Plan

Sharing the results of an assessment with students, parents and administrators also requires careful planning. Generally, the results of formative assessments do not need to be communicated beyond the classroom, but the results of summative assessments are usually shared with a larger audience. Sample ques-

tions the teacher might ask as a way of addressing **Steps 18** and **19** are:

- To whom should the results of the assessment be reported? Students? School principal? Other art educators? Other discipline teachers? Parents?
- How much information should the teacher share beyond the classroom?
- What is the best method for communicating assessment results?
- Will the assessment results be placed in the student portfolio? Should parents, in this case, be invited to the next portfolio review process?
- Should results be reported in a norm-referenced context, with the student's standing as compared to his or her classmates? Or, in a criterion-referenced context, with the student's ability to accomplish a criterion indicated by a score?

Formal and *high-stakes* classroom assessments and state-wide assessments require the kind of thorough preparation prescribed in the Art Assessment Guideline. When preparing a traditional test, the teacher uses a portion of the guideline to help clarify thinking and a test blueprint to structure the test. When preparing a performance-based task, use of the entire guideline is necessary. The Guideline challenges the art educator to think through all aspects of an assessment and a task. If the task does not seem to work in the planning stages, then it can be discarded or rewritten. After such a careful planning exercise, the art educator can feel confident that the significant assessments for the task are well-grounded in valid and reliable precedents.

 Assessment Hint

Assessments and assessment results are examples of secondary evidence in a portfolio and can be placed there. You might try reflecting with your students periodically on assessments along with performance examples and other primary evidence gathered in their portfolios. Do not post assessments in the classroom or in any other area which leaves them available for public viewing.

 Assessment Hint

Keep a blank form of the Art Assessment Guideline on hand for the purpose of preparing assessments.

Notes

1 R.J. Stiggins, "Design and Development of Performance Assessments," *Educational Measurement: Issues and Practice* 6, no. 3 (1987): 33–42.

Validity and Reliability

Validity? Reliability? What do these have to do with teaching art? Whatever these terms mean, what do they have to do with me? These are questions the art educator might ask when confronted with the two psychometric terms. Teachers like Isabel Fuentes, Steve White, Ishii Kyoka, Anna Sirokman, and Sally Young might be quite surprised to learn that they probably think about these concepts regularly in their teaching practices.

When Isabel wonders whether she has created the right test or assessment for finding out what she really wants to know about her students' progress, she is addressing validity. When Steve thinks about assessments that have to be efficient as well as effective, he is addressing validity. When Ishii worries about how straightforward her essay test in art history is, she is addressing validity. When Anna thinks about fairness in the tasks she requires students to perform for an important grade, she is addressing validity. And when Sally ponders whether her marks for a student's artwork would be the same as another teacher's marks, she is addressing reliability. In the decisions that teachers make regarding assessment, issues of validity and reliability undoubtedly occur.

Issues of Validity, Reliability, and Item Analysis

Large-scale standardized assessments require that careful attention be paid to issues of validity and reliability. An *item analysis*, an analysis of student responses on assessment or test items, is also a component of the statistical studies conducted on district, state, or national assessments. The art educator involved in assessment initiatives beyond the classroom needs to have a working knowledge of validity and reliability issues as well as item analysis—all of which are critical to sound assessment practices. These psychometric concerns arise even at the classroom level and necessitate thoughtful consideration. A brief overview of each topic is presented.

Validity

Validity is defined as an integrated evaluative judgment based on theoretical rationale and empirical evidence about the soundness of the interpretation of assessment results and the usefulness of results for their intended purpose. In other words, inferences

drawn from a test or assessment score need to be validated.

In the past, only a limited number of performance-based assessments were conducted on a large scale. For this reason, validity issues concerning performance-based assessment have only recently garnered attention in the measurement field. Pencil-and-paper types of tests have long been the standard fare for large-scale testing practices in the United States. Current interest in performance-based assessments, however, has outdistanced study and research in psychometric issues related to the topic. Experts in the field of tests and measurement are still debating whether performance assessments require unique validation criteria.

There are twelve validation criteria that are useful for judging the validity of performance-based art assessments. Criteria should be addressed during the crafting of the performance task. To what degree each criterion must be met or satisfied is a subjective decision. No set formulas exist for determining levels or degrees of correctness. The concept of *intersubjectivity*, that is, a subjectivity that is decided upon by experts in the field and/or the group responsible for making such decisions, can be extremely useful in this circumstance.[1] In short, a balanced judgment of validity is sought based on criteria concerned with different kinds of evidence and with consequences.

Validation Criteria for Performance-Based Assessments

The following criteria, although discrete, also intertwine and overlap. Some are more relevant and applicable, in varying degrees, to performance-based assessment tasks at the classroom level. Large-scale assessments, however, should address all of these criteria.

By using these validation criteria, the art educator can verify soundness of his or her classroom assessment practices. For the art educator or administrator involved in district, state or national testing initiatives, the criteria provide not only a rudimentary understanding of the complexities of validity but also a foundation for establishing validity in large-scale assessments.

1 Relevance

Relevance refers to the quality of fit between the purpose of the assessment and selected performance format and tasks. The art educator should look for the best possible match between purpose and assessment performance formats.

2 Content Fidelity and Integrity

Content fidelity and integrity refers to the authenticity of assessment task content. The assessment task must faithfully reflect the integrity of the discipline and clearly show the field's most time-tested and valuable content and processes.

3 Exhaustiveness

Exhaustiveness refers to the scope and comprehensiveness of performance task content and underlying *constructs*. *Constructs* are the internal qualities and behaviors that undergird a performance.

Traditionally, comprehensive coverage of a domain has been most desirable in assessments. To this end, paper-and-pencil tests, particularly multiple-choice items, have been extremely successful, assessing a wide variety of objectives and covering exhaustive material in a time- and cost-efficient manner.

Performance-based tasks, because they require in-depth approaches to an idea, process, or product, assess only a slice of content in a discipline or domain. A slice of content cannot be used to generalize judgments about students' broad knowledge of a discipline. Boundaries must be assigned to a

performance-based score to understand what the performance actually means. Teacher inferences made from students' scores about the depth of learning have more credibility when the performance task emphasizes in-depth coverage of content, rather than breadth of content. Students must have had an opportunity to learn all the content, including all constructs, concepts, methods of inquiry, and materials, covered in the performance-based assessment task.

4 Cognitive Complexity

Cognitive complexity refers to the levels of intellectual complexity the performance task requires of students. Ideally, the task will provide a rich source of information concerning student progress, including knowledge of content, procedures, conditions, skills, metacognitions, and attitudes pertaining to the discipline or domain of interest. An example of cognitive complexity is a holistic performance-based task that covers each of the four visual arts disciplines, their interconnections, and their connections to the other academic disciplines.

5 Equity

Equity refers to the extent to which a task allows equal opportunities for all students to succeed. Performance tasks must be demonstrably equitable and appropriate, and their scores, a suitable vehicle from which to make inferences. The art educator can create a checklist of possible sources of bias to be used to review the task as it is being developed. Chart 7 on page 143 presents a possible model.

6 Meaningfulness

Meaningfulness refers to how motivating, challenging, and satisfying a task is to both students and others who might have interest in the task, such as parents, other teachers, administrators, and experts from the art disciplines. Understanding of assessment as both a *didactic* (instructional) and *dialectic* (stimulating

arguments that discriminate truth from error, reason from opinion) tool, provides a philosophical basis for the creation of thought-provoking tasks that empower students to make independent, meaningful, and new connections.

7 Straightforwardness

Straightforwardness refers to students' need to see and understand what is expected of them. In assessment terminology this is known as *transparency*. Some experts argue for the fluidity of an assessment task, that is, the opportunity to openly discuss, clarify, and even modify the task after discussion with students.

8 Cohesiveness

Cohesiveness refers to the homogeneity of exercises in a performance. In a field with four distinct underlying disciplines (art history, art criticism, aesthetics, art production), where comprehension is determined by an understanding not only of the separate disciplines but also of their integration, cohesiveness of a complex holistic task needs to be examined before the assessment is implemented. If the holistic task score is to be interpreted as a valid measure of knowledge of the visual arts, then each exercise within the task should correlate well with the others.

9 Consequences

Consequences refer to both intended and unintended consequences of a task or of interpretation of task scores. The art educator can address the consequential criterion by anticipating possible assessment side effects, both negative and positive, and hypothesizing potential testing outcomes.

10 Directness

Directness refers to the extent to which the task reflects the actual behavior or characteristic being examined. A *direct assessment* of students' abilities to criticize a work of art would be to have them write a critical review. Knowledge and skills cannot be assessed directly but, rather, are inferred from per-

formances and products. Therefore, the less direct a task is in structure, the less true might be the information it yields. An example of a task with a less-than-direct structure is a multiple-choice series of questions. Multiple-choice questions about a model for criticizing a work of art tells the teacher much less about students' abilities to criticize than their written critical review. An assessment with a structure that is considered direct allows students to complete the task freely, unfettered by structured test items or restricted-response item formats.

11 Cost and Efficiency

The value of the performance task must override the cost, and performance assessments generally cost more than multiple-choice or other pencil-and-paper test formats. The projected cost for the proposed 1996 NAEP Arts Assessment, which originally featured performance-based tasks in the disciplines of dance, music, theater, and visual arts, exceeded $20,000,000, making it the most costly of any previous NAEP assessments. (This expense is a major reason why the assessment was delayed for one year and why it turned out to be only a probe, a smaller-scaled study with fewer sampled students, of grade eight students in music and visual arts.)

In terms of efficiency, art educators should also consider the subcriterion *data availability* and *practicality* for obtaining data. Observing students for scoring purposes should not interfere with their performance or jeopardize their opportunities to succeed. The environment of the performance should allow data to be easily gathered. In short, all aspects of a performance assessment should be carefully studied in an effort to devise ways to reduce costs and increase efficiency.

12 Generalizability

Generalizability refers to the degree to which the results of a performance assessment can be general-ized across different domains. Ideally, performance tasks should lend themselves to making broad but accurate generalizations with a high level of predictability. In themselves, scores for individual performance tasks are seldom of great interest; but scores on numerous performances, which make possible valid generalizations about knowledge in a field, are of great interest.

Contextual can be considered a subcriterion of generalizability because it is concerned with issues of transfer and generalizability. Good authentic performance tasks are often highly context-specific, because they relate to the students, environment, culture, beliefs, and values of the particular school and community in which they are administered. Generalizing the results of a context-specific task to the field at large cannot be done. The fact that a student scored very high on an assessment task based around regional landmark artists, does not mean score results can be interpreted as proof that the student has excellent knowledge of American art history. Classroom settings, classroom management effects, and even rater variability are contextual issues that need to be analyzed before making judgments of transfer.

Reliability

Closely related to validity is the concept known in classical tests and measurement theory as *reliability*. *Reliability* can be defined as the consistency of assessment scores. How many times the same assessment, when repeated under the same conditions, would be given the same score lies at the heart of reliability. Interestingly, an assessment can be reliable, that is, repeated again and again with the same score results, without being valid—but an assessment can never be valid without being reliable. Put another way, reliability affects the quality of the

decisions made on the basis of the derived score, which is validity. Unreliable results are never valid.

For the art educator, it is worthwhile to know what factors might cause an unreliable assessment score. The most significant factor is related to scoring: inconsistent marks resulting from the idiosyncrasies of the person(s) marking the student's performance. When two people rate a performance, then the concept of *inter-rater reliability*, that is, the consistency of scores assigned by different raters, becomes a consideration. If two raters' scores correlate well, then there is a high degree of inter-rater reliability. If great differences exist between scorers' marks, then a low degree of inter-rater reliability results. Various rating errors are discussed in Chapter 4, under the topic of Rating Scales (page 63). Understanding why these errors occur and attempting to reduce them improves the reliability of students' art performance scores.

Following the procedures listed below will also help improve the reliability and generalizability of art assessments:

- Assess the same material, using multiple measures, frequently. Use a combination of assessment results to make grading decisions.
- Broaden the scope of assessments by making them longer with more observations, questions, or tasks.
- Develop clear and concrete scoring criteria.
- Make scoring as objective as possible by developing a scoring rubric.
- Create annotated examples illustrating each score or performance level.
- When possible, use more than one scorer. Try, for example, two scorers and a possible third scorer as a backup should the scores of the first two be quite far apart.
- Should more than one judgment be necessary, train scorers, give them opportunities to practice

scoring, and see to it that they agree upon meaning of criteria and intend to strive for a high degree of consistency between themselves before judging begins.
- Check consistency during scoring process by occasionally going back and rechecking the scores of several students' work.
- Score one question for all students, and then go back and score another question for all students.
- Teach students how to perform at their best by providing practice and training in assessment procedures.[2]
- Match assessment difficulty to students' abilities by crafting tasks to fit each student's abilities.[3]
- Design some tasks that help differentiate the most able from the least able students. A wide range of abilities should be made apparent on a task.[4]

Item Analysis

A third psychometric issue that warrants brief discussion is *item analysis*. Item analysis is "the process of collecting, summarizing, and using information from students' responses to make decisions about each assessment task."[5] Item analyses determine if an item functions as it is intended, which items are most difficult, and how certain groups of students respond to each item. On the basis of an item analysis, certain tasks may be retained, revised, or discarded for future assessments.

A relatively simple item analysis on an important classroom test of the pencil-and-paper type can be conducted without knowing the formulas for item indices of difficulty and discrimination. First, the teacher needs to group the assessments according to high and low scores. Second, tallies are made of each group's responses on each test item. Third, percentages for item responses are figured. If the difference

between percentages of the high-scoring group and the low-scoring group is small, for either correct responses or incorrect responses, then the item is called into question and studied for inherent problems. On the basis of an item analysis, certain items or tasks may be retained (banked), revised, or discarded. Feedback to both teacher and student results from a thoughtful analysis of assessment or test items.

Validity, reliability, and item analysis are major psychometric issues in the field of tests and measurement. They involve use of many different statistical indices, beyond the scope of this book, for interpreting them precisely as a psychometrician would do. The art educator interested in more discussion of these three complex psychometric issues is encouraged to read a basic tests and measurement book such as *Educational Assessment of Students* (Nitko, 1996), *Essentials of Psychological Testing* (Cronbach, 1990), or *Educational Measurement* (Linn, 1989).

A final note on assessment emphasizes its importance in the scheme of education. Worldwide studies of student achievement in various academic subjects have revealed what is required to be world class.[6] Four of the five identified factors are concerned with assessment. The five factors are:
- a common core curriculum
- assessment aligned with the core curriculum
- assessment in the domain of educators
- assessments that are not kept secret, but shared and open to the public
- assessments that have consequences

These critical factors challenge the art educator to establish assessment practices in the classroom and beyond that will help contribute to world class art education in America.

Assessment Hint

The last reliability strategy might at first glance be confusing and appear to contradict the preceding item. When students have similar abilities, some assessment tasks should be designed to help discriminate between those who know the material and those who do not and may only be guessing. In a classroom situation with students of very similar abilities, it can be difficult to distinguish between them on an assessment. When students evidence very disparate art abilities, the art educator should design assessment tasks that highlight those differences and see to it that scores are interpreted with care and appropriately.

Large-scale assessments require high levels of reliability, particularly if the results of test scores will have considerable consequences. Because of their subjective nature, performance-based assessment tasks present special reliability problems and, therefore, demand the use, when appropriate, of a well-defined scoring rubric.

Notes
1 C. Sluijter, personal communication, 16 August 1994.
2 Nitko, 1996.
3 Nitko, 1996.
4 Nitko, 1996.
5 Nitko, p. 308.
6 Matt Gandal, American Federation of Teachers, presented at a panel discussion at the 27th Annual Assessment Conference, Colorado Springs, CO, 1997.

Appendix

Appendix A Core Curriculum Skills

1 Recognizing letters, words, and other symbols
2 Finding material in an indexed collection
3 Searching and locating items/information
4 Recalling/remembering
5 Taking and reviewing notes
6 Recognizing processes for recalling information
7 Interpreting the meaning of words or other symbols
8 Interpreting the meaning of pictures/illustrations
9 Interpreting the meaning of tables, diagrams, maps, graphs
10 Translating from one form to another
11 Using correct spelling, grammar, punctuation
12 Using vocabulary appropriate to a context
13 Paraphrasing
14 Outlining and ranking
15 Summarizing/condensing written text
16 Analogizing and making connections
17 Compiling lists/statistics
18 Recording/noting data
19 Compiling results in a tabular form
20 Graphing
21 Gridding
22 Calculating with or without calculators
23 Estimating numerical magnitude
24 Approximating a numerical value
25 Substituting in formulae
26 Setting out/presenting/arranging/displaying/exhibiting
27 Structuring/organizing information or extended written text
28 Grouping/ordering/categorizing information
29 Structuring/organizing a mathematical argument
30 Explaining to others

31 Expounding a viewpoint
32 Comparing and contrasting
33 Classifying
34 Interpreting ideas/themes/issues
35 Recognizing underlying principles/rules
36 Reaching a conclusion which is necessarily true provided a given set of assumptions is true
37 Reaching a conclusion which is consistent with a given set of assumptions
38 Inserting an intermediate between members
39 Extrapolating
40 Applying strategies to trial and test ideas/procedures
41 Applying a progression of steps to achieve the required answer
42 Generalizing from information
43 Elaborating information by using mental or symbolic images
44 Establishing goals and determining if they are met
45 Hypothesizing
46 Criticizing
47 Analyzing
48 Synthesizing
49 Judging/evaluating
50 Justifying
51 Creating/composing/devising/inventing
52 Reflecting
53 Modifying practices
54 Perceiving patterns
55 Visualizing
56 Identifying shapes in two and three dimensions
57 Observing systematically
58 Gesturing
59 Manipulating/operating/using equipment/tools
60 Sketching/drawing

Based on a model from the Board of Senior Secondary School Studies, Queensland, Australia.

Chart 1 Products and Processes of the Visual Arts Disciplines (Reference Chapter 1, page 3)

Art History	
Sample Products Art-historical report, timeline, dramatizations, exhibition catalog, field notes, dialogues, correspondence letters/postcards, art museum room	*Sample Processes* Observing, perceiving, setting a problem, analyzing, seeking evidence and counterevidence, constructing support, describing, classifying, interpreting, comparing and contrasting, inventing, giving reasons, evaluating, analyzing errors, reordering and revising, making and judging value judgments, presenting a position or argument (oral or written)

Art Criticism	
Sample Products Critical review, correspondence letters/postcards, criticism model, dialogues, dramatizations	*Sample Processes* Observing, describing, explaining, characterizing, analyzing, seeking evidence and counterevidence, constructing support, interpreting, comparing, inventing, giving reasons, evaluating, analyzing errors, reordering and revising, making and judging value judgments, presenting a position or argument (oral or written)

Aesthetics	
Sample Products Theory development, correspondence letters/postcards, dramatizations, diary	*Sample Processes* Observing and listening, puzzling and questioning, setting a problem, analyzing arguments, applying known information to new situations, comparing, making and judging value judgments, constructing support, reasoning, inducing and deducing, extending premises, inferring, inventing, describing, defining, evaluating, analyzing errors, reordering and revising, presenting a position or argument (oral or written)

Art Production	
Sample Products Art object, art prospectus, demonstrations, experimentations	*Sample Processes* Generating ideas, setting a problem, observing, recalling, analyzing, classifying and discriminating, exploring and experimenting, inventing, abstracting, selecting criteria for possible solutions, extrapolating findings to other situations, considering alternatives, reviewing and evaluating, analyzing errors, making and judging value judgments, reordering and revising, synthesizing, reflecting, evaluating, verifying, exhibiting

Chart 2 Portfolio Holistic Scoring Rubric (Reference Chapter 2, page 16)

Standard 1 Very Limited Achievement (Serious Problems)	*Standard 3* Sound Achievement (OK)	*Standard 5* Very High Achievement (RAD!)
• The student's portfolio is incomplete and lacks organization. • Research is inadequate, resulting in studio or written work that is not resolved and totally dependent upon teacher for direction and guidance. • No problem-solving processes are evident in entries, and the student has not been able to utilize feedback and make revisions to work. • An understanding of visual language, structures, or form as applied to work is rarely seen, and ideas are copied from other sources. • All entries, whether studio or written, show minimal or no influence of various impacting contexts such as personal, social, cultural, historical, aesthetic, and the like. • No connections are made to other content areas or to daily life. • The student is unable to reflect upon, critically discuss, or assess with a set of appropriate criteria his/her own work and that of others. • Entries indicate absence of an intellectual or a creative curiosity that drives successful work. • The portfolio shows minimum improvement over time and exemplifies very limited achievement toward stated goals and objectives.	• The student's portfolio is complete with required entries and is presented in a satisfactory manner. • An intellectual and creative curiosity frequently develops to help drive work. • Portfolio evidence suggests research is usually sound and often self-directed, leading to successful resolution of most works. • Tasks often exhibit a personalized and expressive approach and some ideas are quite meaningful and important. • With occasional guidance from the teacher, the student is able to transform feedback into acceptable or good results. • Generally speaking, work shows effective application of visual language, structures, or form. • Basic knowledge of several contexts (e.g., personal, cultural, historical, and technological) undergirding studio and written entries is evident. Moreover, a few meaningful connections are made to other disciplines and to daily life as well. • In most cases, the student can reflect upon, critically discuss via a model, and assess with appropriate criteria his/her own work and that of others. • Portfolio indicates satisfactory improvement over time and proficient achievement toward stated goals and objectives.	• The student's portfolio is complete, with far more evidence than is required, and presented in a slick, professional-like manner. • A passionate and keen intellectual and creative curiosity regarding work is apparent in all entries. • In-depth and adventurous research and an expressive approach to art have resulted in resolution of ideas and tasks that are complex, conceptually strong, and reveal a clear personal signature. • Feedback, when given, has been combined with a personal response to problems, and revisions are extremely successful. • Knowledge and skills pertaining to visual language, structures, forms, and vocabulary are highly developed and applied to work. • Entries reveal comprehensive knowledge of many contexts (e.g., personal, social, cultural, historical, philosophical, technological, environmental, economic, aesthetic) surrounding and influencing work. • The student is able to reflect upon, critically discuss via a model, and assess with appropriate and internalized criteria his/her own work and that of others. Through discussion of the portfolio, a personal value and belief system can be inferred. • Overall, the portfolio shows highly significant improvement over time and outstanding achievement toward stated goals and objectives.

Chart 3 Portfolio Analytic Scoring Rubric

Criterion	Standard 1 Very Limited Achievement (Serious Problems)	Standard 2 Limited Achievement (Not So Hot)
Researching • selection and development of themes, problems, issues, techniques, and processes through study, research, or exploration • variety of appropriate sources	The Student: • is unable to plan or conduct research without continuous help, therefore, selection, development, or solution of themes, problems, issues, techniques, or processes is entirely dependent on teacher • makes no deliberate attempt to explore appropriate sources	The Student: • with frequent teacher help is able to plan and conduct research that leads to selection, development, or solution of a few satisfactory themes, problems, issues, techniques, or processes • selects a few appropriate sources for answers
Creating • personalized and expressive approach in the area of study • conceptual importance • intellectual and creative curiosity that drives art study and work • demonstration of knowledge and skills pertaining to visual language, structures, forms, and vocabulary	The Student: • fails to establish an appropriate working or problem-solving process and needs constant direction • copies ideas from other sources • lacks desire to explore work intellectually or creatively • shows minimal application of learned knowledge and skills pertaining to visual language, structures, forms, and vocabulary	The Student: • works in a haphazard manner with little understanding of a successful problem-solving process and requires frequent direction • exhibits ideas that are generally mundane and trivial • at times shows a spark of intellectual or creative curiosity toward work • occasionally shows deliberate application of learned knowledge and skills pertaining to visual language, structures, forms, and vocabulary with some success
Responding • responsiveness to personal, social, cultural, historical, philosophical, technological, environmental, economic, and aesthetic contexts and stimuli in the area of study • demonstration of description, classification analysis, interpretations, and judgment of information and art images • responsiveness to feedback • depth of revision	The Student: • demonstrates no understanding of various contexts (personal, social, cultural, historical, philosophical, technological, environmental, economic, aesthetic) surrounding and impacting work • demonstrates an inability to describe or analyze information and art images. Analyses are inaccurate and unclear. • is unable to utilize feedback to improve work • is unable to make revisions to work	The Student: • demonstrates limited knowledge of a few contexts (personal, cultural, historical) surrounding and impacting work • demonstrates limited ability to describe, classify, and analyze information and images. Analyses and conclusions are often unclear or inaccurate. • responds to feedback with occasional success • makes a few successful revisions to work

Standard 3 Sound Achievement (OK)	*Standard 4* High Achievement (Good Job)	*Standard 5* Very High Achievement (RAD!)
The Student: • is often self-directed in planning and conducting research which contributes to successful selection, development, and solution of most themes, problems, issues, techniques, or processes • uses several meaningful sources to gather information	The Student: • conducts sufficient planning and research enabling selection, development, and solution of complex and personal themes, problems, issues, techniques, or processes • uses a wide variety of appropriate sources and means to find information	The Student: • demonstrates exemplary ability to plan and conduct in-depth, personal, and adventurous research which results in highly successful solution of complex themes, problems, issues, techniques, or processes • utilizes a vast amount and variety of appropriate sources and means to gather information
The Student: • may work in a personalized and expressive manner in some instances, but is occasionally dependent on guidance • develops ideas that are sometimes meaningful or important • frequently exhibits an intellectual and creative curiosity that drives work • is usually able to apply learned knowledge and skills pertaining to visual language, structures, forms, and vocabulary with frequent success	The Student: • nearly always approaches work in an independent and expressive manner • develops ideas of conceptual importance • is inquisitive with regard to work and willing to explore it intellectually and creatively • demonstrates successful application of learned knowledge and skills pertaining to visual language, structures, forms, and vocabulary	The Student: • approaches all work in a highly individualized and expressive manner and is able to direct own process • develops ideas that are conceptually strong and reveal important insights • demonstrates a passionate and keen intellectual and creative curiosity toward work • exhibits highly developed abilities in successfully applying learned knowledge and skills pertaining to visual language, structures, forms, and vocabulary
The Student: • demonstrates rudimentary knowledge of several contexts (personal, cultural, historical, technological) surrounding and impacting work • demonstrates ability to describe, analyze, interpret, and judge information and images. Analyses and conclusions are usually correct. • employs feedback with satisfactory results • is able to revise work for acceptable results	The Student: • demonstrates broad knowledge of various contexts (personal, social, cultural, historical, philosophical, technological, environmental, economic, aesthetic) surrounding and impacting work • is able to describe, analyze, interpret, and evaluate information and images with justification. Analyses and conclusions are accurate and consistent with data. • responds to feedback with personal insight and uses it to achieve successful results • revises work when necessary with successful results	The Student: • demonstrates a comprehensive knowledge of many contexts (personal, social, cultural, historical, philosophical, technological, environmental, economic, aesthetic) surrounding and impacting work • describes, analyzes, interprets, and evaluates information and images with sound reasons and insight that reflect a value system. Analyses and conclusions are accurate, detailed, insightful, valid, and consistent with data • responds to feedback with personal insight and incorporates own ideas and suggestions • revises work when necessary with highly successful outcomes

Chart 3 Portfolio Analytic Scoring Rubric (continued)

Criterion	Standard 1 Very Limited Achievement (Serious Problems)	Standard 2 Limited Achievement (Not So Hot)
Resolving • personalized and expressive solutions to problems or tasks in area of study • completeness of collection (depth and breadth of entries) • achievement of predetermined goals and objectives (student's, teacher's, school's) • improvement from past performances	The Student: • attempts to solve problems or tasks but without resolution • has completed very little of required work • shows very limited achievement toward stated goals and objectives • fails to show improvement from past performances	The Student: • has solved problems or tasks in a largely derivative manner lacking personal expression • is missing some pieces of required work • shows limited achievement toward stated goals and objectives • demonstrates some improvement from past performances
Communicating • presentation • demonstration of self-reflection and self-assessment • connection to other content areas and to daily life	The Student: • presents work in an unsatisfactory manner with no organization • is unable to discuss, reflect upon, and evaluate work including his/her own. Cannot discriminate between degrees of quality in work. • makes no connections to other content areas or to daily life	The Student: • makes some attempt to present work in an organized and acceptable manner • has difficulty discussing, reflecting upon, and evaluating work including own. Rarely identifies own strengths and weakness or discriminates between degrees of quality in work. • seldom makes connections to other content areas and daily life

Portfolio Analytic Scoring Rubric (continued)

Standard 3 Sound Achievement (OK)	*Standard 4* High Achievement (Good Job)	*Standard 5* Very High Achievement (RAD!)
The Student: • has solved some problems or tasks in an expressive manner showing a personalized approach • has completed all required work • shows satisfactory achievement toward stated goals and objectives • has improved satisfactorily from past performances	The Student: • has solved most problems or tasks in a personalized and expressive manner • has completed all required work and included several extra examples • shows high achievement toward stated goals and objectives • demonstrates above average improvement from past performances	The Student: • has solved all problems or tasks in a highly expressive manner showing a clear personal signature • has completed all required work and included a wide assortment of extra studies or examples • shows outstanding achievement toward stated goals and objectives • shows highly significant improvement from past performances
The Student: • presents work in a cohesive and satisfactory manner • is usually able to discuss, reflect upon, and evaluate work including his/her own. In most cases, recognizes own strengths and weakness and can identify varying degrees of quality in work. • makes some meaningful connections to other content areas and daily life	The Student: • presents and organizes work effectively • discusses, reflects upon, and evaluates work including his/her own. Demonstrates ability to recognize and discuss own strengths and weaknesses as well as to discriminate between varying degrees of quality in work. • makes relevant connections to other content areas and daily life	The Student: • presents work in a well-organized, slick, and professional manner • discusses, reflects upon, and evaluates work, including his/her own, with astute personal insight. Demonstrates a clear understanding of own personal development and can easily discriminate between varying degrees of quality in work. Manifests internalized self-assessment and personal value systems. • makes multiple relevant connections to other content areas and daily life

Chart 4 Integrated Performance Strategies (Reference Chapter 2, page 24)

To Assess Students' Knowledge of Content and/or Methods of Inquiry in:	Sample Performance Task
1 Dramatizations	
the four disciplines . . .	• role play the aesthetician, the art critic, the art historian, and the artist
aesthetics . . .	• dramatize a Senate hearing about an art issue • dramatize a community/public town meeting about a proposed community artwork • act out or pantomime the different aesthetic theories
art history . . .	• act out the subject matter of a painting • create a play or pantomime about an artist's life
art history or aesthetics . . .	• act out "a significant day in the life of" an artist or philosopher • dramatize a radio or TV talk show (or a popular sitcom) focusing on a controversial art subject (from history of art) or issue • conduct a British Debate (after several minutes of arguing, students switch positions and offer new arguments) about a controversial art issue or art theory
art history or art criticism . . .	• put a controversial artwork or artist on trial
art world (art auctions) . . .	• dramatize an art auction
2 Extended Written Projects	
art history . . .	• write an illustrated art-historical report based on an original art history problem (see Assessment Strategy 4) • write an art exhibition catalog • create an illustrated travel brochure of important art works to see on an "Art Tour" travel itinerary • create the provenance or the creation of an artwork by having the artwork tell its personal story • write a book of poetry about artworks or artists or a series of poems that corresponds with the defining characteristics of certain art-historical movements (e.g., abstract expressionist poetry, photorealist poetry, cubist poetry, pop art poetry, conceptual poetry and the like) • write a personal art history referenced to art-historical movements • create field notes of the art historian based on a series of questions the art historian would answer about a work of art
all four disciplines . . .	• create a dialogue (written or oral) between two artists or philosophers seated next to each other at a dinner party or at an opening exhibition

Integrated Performance Strategies (continued)

To Assess Students' Knowledge of Content and/or Methods of Inquiry in:	Sample Performance Task
2 Extended Written Projects, cont.	
all four disciplines, cont. . . .	• write a series of letters between two artists (historical and/or contemporary), two philosophers, or an artist and a critic • create an art newspaper for the avant garde reader • create the personal diary of an artist, philosopher, or critic • create a dialogue (written or oral) between two puppet characters, Rant and Rave, about an art-related issue or topic
3 Novel Written Projects	
aesthetics . . .	• write original aesthetics puzzles • disprove a common aesthetics theory (e.g., mimetic) • write an original children's story based on an aesthetics question, tell the story as a storyteller would
aesthetics or art history . . .	• write several art reproduction postcards to a philosopher or art historian asking field-related questions or stating important ideas about aesthetics issues (see Assessment Strategy 5)
art history . . .	• develop an original illustrated art history timeline • write didactic labels for artworks in a local exhibition or for some obscure artwork in an art museum which is lacking information • create an oral history of an art movement, and include what various people from different walks of life might have said about artworks of that particular style or period
art history or art criticism . . .	• write postcards to a friend at home describing an art exhibition or work by a particular artist • write a letter to an art historian, a critic, an artist, or the editor of a journal or newspaper arguing a personal point of view about an art issue or art object
art history, art criticism, aesthetics . . .	• write a newspaper headline and article about a landmark artist, an artwork, an art-historical movement, or an early aesthetician's belief as it might have appeared during its original time period
all four disciplines . . .	• create a series of metaphors combining art ideas and science • write a campaign speech for an artist (or aesthetician, critic, or historian) who is running for "Artist of the Decade" (or "Aesthetician of the Century," "Critic of the Year," and so forth) • create a series of quotations that famous artists, art historians, art critics, or philosophers might have said

Chart 4 Integrated Performance Strategies (continued)

To Assess Students' Knowledge of Content and/or Methods of Inquiry in:	Sample Performance Task
4 Individual Student Projects	
aesthetics . . .	• develop a collage based on a circle showing "What's In" and "What's Out" with respect to one's own definition of art • create logic puzzles based on art issues
art history . . .	• develop a pie chart showing percentage of time throughout history of mankind for each art-historical movement • create an art history tree showing an art movement's roots, branches, and leaves • create a dance (or creative movement) based on art-historical movements and related media techniques (e.g., abstract expressionism and action painting)
art history, art criticism, aesthetics . . .	• develop a series of posters about artists, art movements, aesthetic beliefs, or important art questions (e.g., "What's Hot and What's Not" format)
art history or art criticism . . .	• create a series of mathematical formulas, problems, rations, percentages, and the like to describe an artwork mathematically • write and perform a rap musical piece about an artist or artwork • rewrite a popular song with lyrics about an artist or artwork and sing it • create a musical score for an artwork with notes and symbols based on composition, shapes, or colors. Play the music. • develop a musical tape of songs and sounds that suggest the characteristics of a particular historical or contemporary art accompanied by an explanatory text (e.g., an Op Art or Conceptual Art Tape)
art history or art production . . .	• create a series of adventure comic books or cartoon characters with a story board based on art movements (e.g., Dada Man, Baroque Woman, Cubist Man, Op Man, Pop Woman, Minimalist Man, and the like) • develop an original illustrated text about several art-historical movements (e.g., A Book of Five Art "Isms")
art criticism or aesthetics . . .	• create a personal model of criticism or aesthetic belief based on several existing models or beliefs
art production . . .	• create a unique way to exhibit an original work • develop an art book based on an original theme
all four disciplines . . .	• develop a diagram pertaining to some art-related issue or problem • create an art game based on well-known games • create an original art game

Integrated Performance Strategies (continued)

To Assess Students' Knowledge of Content and/or Methods of Inquiry in:	Sample Performance Task
5 Group Projects	
aesthetics . . .	• restore an "ancient" art object addressing issues surrounding restoration
aesthetics or art criticism . . .	• conduct a survey about a controversial art-related issue or artwork
art history or art production . . .	• plan (and create) a dinner party for a guest list of diverse artists, with table service, table decorations, menu, and entertainment that each might enjoy
art history, art criticism, aesthetics . . .	• create an art game that uses other languages
art production . . .	• create an example of performance art or an installation
all four disciplines . . .	• create a model art museum room (see Assessment Strategy 6) • create a newly discovered unique culture with a rich artistic heritage • design a bulletin board about some art-related subject
art in public places . . .	• develop a map and key (can be a 3-D map) of a community's artworks
art in public places and aesthetics issues . . .	• include in the map a description of a major aesthetics issue that surrounds each community art piece
6 Simulations and Contrived Situations	
aesthetics or art production . . .	• replicate a work of art and discuss all surrounding issues
art history . . .	• simulate a "who done it" mystery about an artwork with clues for solving it (see Assessment Strategy 7)
7 Demonstrations	
art history or art production . . .	• demonstrate how the camera obscura works
art production . . .	• demonstrate different painting, printmaking, or sculpture techniques • demonstrate the color wheel through dance • demonstrate steps of an art process through visual images or pantomime
8 Experiments	
art production . . .	• experiment with a pinhole camera and take a series of photographs • experiment with unique glazing techniques, creating a series of small exemplar tiles • experiment with new tools for drawing or painting

Chart 5 Test Blueprint (Reference Chapter 6, page 105)

Content Outline	Behaviors					
	Recall	Analysis	Comparison	Inference	Evaluation	Totals
Subject Matter		test item				1
Artist	test item		test item			2
Elements, Principles		test item				1
Context	test item			test item		2
Source/Precedents				test item		1
Materials/Techniques	test item	test item				2
Iconography	test item				test item	2
Art Theory				test item	test item	2
Totals	**4**	**3**	**1**	**3**	**2**	**13**

Behaviors are based on the Quellmalz's taxonomony of the cognitive domain.

Chart 6 Exit Levels of Achievement (Reference Chapter 6, page 107)

VHA = Very High Achievement (RAD!)	VHA	Standard 5 in any four of the exit criteria and no less than a 4 in the remaining criterion.
HA = High Achievement (Good Job)	HA	Standard 4 in any four of the exit criteria and no less than a 3 in the remaining criterion.
SA = Sound Achievement (OK)	SA	Standard 3 in any four of the exit criteria and no less than a 2 in the remaining criterion.
LA = Limited Achievement (Not So Hot)	LA	Standard 2 in any four of the exit criteria.
VLA = Very Limited Achievement (Serious Problems)	VLA	Standard 1 does not meet the requirements for Limited Achievements.

Chart 7 Checklist of Possible Bias Sources (Reference Chapter 8, page 126)

Did I consider . . .	Comments
☐ **1** the mean differences of particular groups (e.g., gender, ethnicity) in other assessment tasks similiar to this one? Have all groups been given the same opportunities to perform this type of task? If some group has an average score much lower than the average score of other groups, then the assessment may have a ***bias of mean differences***.	
☐ **2** the constructs (educational or psychological attributes, traits, or mental processes) undergirding a task? Are all required skills and knowledge in the task relevant for intended assessment use and score interpretation?	
☐ **a** the internal task structure? Is a part of the task or task exercises unfair for some students? If constructs embedded in a task do not fit the intended use of the assessment and internal task structure or exercises are unfair for some students, then the assessment is said to have a ***construct bias***.	
☐ **3** the content and format of the task? Are they appropriate for assessment use and interpretation of outcomes?	
☐ **a** sexist content? Are language and images relating to the task sexist in nature? Is gender role stereotyping evident in the task?	
☐ **b** racial content? Are language and images relating to the task racist in nature? Is racial stereotyping evident in the task? Sexist and racist content create a ***facial bias***.	
☐ **c** the differences in experience of students? Are some students' life experiences likely to cause them to perform poorly on the task? A ***content and experience bias*** occurs when some groups' life experiences differ vastly and are not taken into consideration when creating the task and interpreting the results.	
☐ **4** the administration of the task? Are administration procedures equal (standardized) for all students? Are task directives equal for all groups?	
☐ **a** how facilitator and students will be prepared for administering the task?	
☐ **b** how students will be monitored during the task?	
☐ **c** how administration of task will affect the performance of students? Particular groups of students? An ***administration bias*** occurs when standardization procedures are not set or followed precisely. Students should know that they will be assessed, on what they will be assessed, reasons for the assessment, and how results will be used (Nitko, 1996, p. 363).	
☐ **5** if scoring of task is objective enough? Is it too subjective? A wrong or insufficient scoring method can create a ***scoring bias***.	
☐ **a** if score interpretations might go beyond what task content actually supports? Interpretation of scores needs to be in line with what can be inferred from task content. If too much is inferred, or too little, then a ***misinterpretation of score bias*** occurs.	

Bibliography

Addiss, S. And M. Erickson. *Art History and Education*. Urbana and Chicago: University of Illinois Press, 1993. Provides information on teaching art history in the K–12 curriculum.

Airasian, P.W. *Classroom Assessment*. New York: McGraw-Hill, Inc., 1991.

———. "Perspectives on Measurement Instruction." *Educational Measurement: Issues and Practice* 10: 1 (1991): 13–16. Basics on tests and measurement.

Angelo, T.A. and K.P. Cross. *Classroom Assessment Techniques*. 2d ed. San Francisco: Jossey-Bass, Inc. Publishers, 1993. Provides basics on classroom assessment strategies, primarily for university settings.

Armstrong, T. *Multiple Intelligences in the Classroom*. Alexandria, VA: Association for Supervision and Curriculum Development, 1994. Describes application of multiple intelligences theory in the classroom.

Asay, D. *Celebration of Diversity*. Orem, UT: Art Visuals, 1996. A high school curriculum based on the four art disciplines emphasizing cultural diversity.

Cronbach, L.J. *Essentials of Psychological Testing*. 5th ed. New York: HarperCollins Publishers, Inc., 1990. A basic text in tests and measurement directed toward the field of psychology.

Csikszentmihalyi, M. *Creativity*. New York: Harper Collins Publishers, Inc., 1996. Explores recent research on creativity including creative attributes.

Cyert, R.M. "Problem Solving and Educational Policy." In *Problem Solving and Education: Issues in Teaching and Research*, edited by D.T. Tuma and F. Reif. Hillsdale, NJ: Lawrence Erlbaum Associates, Inc., 1980. Cognitive research in problem-solving; application to teaching.

Feldman, D.H.; M. Csikszentmihalyi; and H. Gardner. *Changing the World: A Framework for the Study of Creativity*. Westport, CT: Praeger Publishers, 1994. Presents experts' views on issues of creativity.

Gardner, H. *Frames of Mind: The Theory of Multiple Intelligences*. New York: Basic Books, 1983. Introduces the theory of multiple intelligences.

———. "Howard Gardner on Multiple Intelligences." *Scholastic Early Childhood Today*, August/September 1995, 30–32.

Herman, J.L.; P.R. Aschbacher; and L. Winters. *A Practical Guide to Alternative Assessment*. Alexandria, VA: Association for Supervision and Curriculum Development, 1992. Alternative assessment.

Linn, R.L., ed. *Educational Measurement*. 3rd ed. New York: Macmillan, 1989. Comprehensive review of tests and measurement.

Marzano, R.J.; D. Pickering; and J. McTighe. *Assessing Student Outcomes: Performance Assessment Using the Dimensions of Learning Model*. Alexandria, VA: Association for Supervision and Curriculum Development, 1993. Emphasizes critical thinking and the its assessment.

Nitko, A.J. *Educational Assessment of Students*. 2d ed. Englewood Cliffs, NJ: Charles E. Merrill Publishing Co., 1996. A comprehensive text on tests and measurement.

———. *Educational Tests and Measurement: An Introduction*. New York: Harcourt Brace Jovanovich, Inc., 1983.

Parsons, M.J. *How We Understand Art: A Cognitive Developmental Account of Aesthetic Experience*. New York: Cambridge University Press, 1987. Identifies and explains stages in aesthetic development.

Quellmalz, E.S. "Developing Reasoning Skills." In *Teaching Thinking Skills: Theory and Practice*, edited by J.R. Baron and R.J. Sternberg. New York: Freeman, 1985. Research in cognitive psychology and its application to teaching.

Sternberg, R.J. *Beyond IQ: A Triarchic Theory of Human Intelligence*. New York: Cambridge University Press, 1985. Introduces another theory of intelligence, the triarchic model.

———, ed. *The Nature of Creativity*. New York: Cambridge University Press, 1988. Issues involving research of creativity.

———. "Toward Better Intelligence Tests." In *Testing anc Cognition*, edited by M.C. Witrock and E.L. Baker. Englewood Cliffs, NJ: Prentice-Hall, Inc. 1991. Recent research in cognitive psychology and its application to testing.

Weinstein, C.E. and R.E. Meyer. "The Teaching of Learning Strategies." In *Handbook of Research on Teaching*, 3rd ed., edited by M.C. Wittrock. New York: Macmillan, 1986. Recent research in cognitive psychology and its application to testing.

Wiggins, G.P. *Assessing Student Performance*. San Francisco: Jossey-Bass, Inc. Publishers, 1993. Explores purposes and limits of testing while emphasizing performance-based assessments.

———. "A True Test: Toward More Authentic and Equitable Assessment." *Phi Delta Kappan* 70 (1989): 703–713.

G
Gipps, Caroline, 14
grades and marks, 109-112
 borderline cases, plans for, 112
 components of, 110
 distribution of, 110
 explaining meaning of, 110
 meaning of failure and, 110
 model system for, 112
 performance variables and, 110
 standards for, 111-112
 summative assessments and, 109-110
 weighting of components in, 110-111
Great Piece of Turf, 98
group discussion performance assessment strategy, 34-36
growth standards, 111
Guernica, 30-31

H
high-stakes assessments, 105
holistic approach to scoring, 17-18
holistic scoring rubric, 19
 summative assessments scoring and, 107

I
integrated performance strategies, 24-28
 advantages, disadvantages of, 24-28
 audio tapes, video tapes, 38
 computers, 38-39
 exhibitions, 36-38
 group discussions, 34-36
 performance-based versus other strategies, 39
 Postcards to a Friend project, 28-29
 student-constructed performance projects, 30-32
Integrated Performance Strategies (Chart 4), 138-141

inter-rater reliability, 125
interviews
 peer, parent, 71-72
 teacher, 68-71
item analysis, 42, 124, 125, 128-129

J
journals
 assessment of, 23
 defined, 23
 self-assessment and, 74
 sketchbook, 21-22
 use, frequency of, 23
judging tools. See scoring tools

L
La Berceuse, 50
learner reports, 75
learning objectives, 4
logs. See journals

M
master list, 42
maximum performance assessments, 16
Mérode Altarpiece, 26-27
metacognitive skills, 4, 96-97
mini-portfolio, 15, 20
modified holistic approach to scoring, 19
modified holistic rubric, 19
Modersohn-Becker, Paula, 49-50
Mondrian, Piet, 29
multiple validations, 4

N
norm-referencing, 105, 108

O
objective test, 60
objectivity, 60
observations, self-assessment, 76-80
open-ended item, 42
ordinal scales, 60, 64
Our Lady of Good Hope, 51

P
paraphrasing, 94-95
pencil-and-paper test format, 42
percentile rank score, 105
performance assessment strategy, 14-15
performance-based assessments, validation of, 124-127
 cognitive complexity, 126
 cohesiveness, 126
 consequences, 126
 content fidelity and integrity, 125
 cost and efficiency, 127
 directness, 126-127
 equity, 126
 exhaustiveness, 125-126
 generalizability, 127
 meaningfulness, 126
 relevance, 125
 straightforwardness, 126
Picasso, Pablo, 30-31
Poorhouse Woman with Glass Bowl, 49-51
Portfolio Analytic Scoring Rubric (Chart 3), 134-137
Portfolio Holistic Scoring Rubric (Chart 2), 133
portfolios
 annotated, 74-75
 evaluation of, 17-19
 as evidence, 15-16
 interpretation of, 19
 management of, 20
 mini, 20
 purpose of, 15
Postcards to a Friend project, 28-29
preassessment, defined, 4
primary evidence, 16
principles of quality art assessment, 6-10
probe, 60
process, defined, 4
process folio, defined, 15
product, defined, 4

DATE DUE

DEC 1 8 '99			